DOODLE IT ALL!

Doodle It All!
First Published in 2020 by Zakka Workshop, a division of World Book Media, LLC

www.zakkaworkshop.com
134 Federal Street
Salem, MA 01970 USA
info@zakkaworkshop.com

BALLPEN IRASUTO DAI SHUGO (no. 1336)
All rights reserved. Copyright ©2016 Boutique-sha
Originally published in Japanese language by Boutique-sha, Tokyo, Japan
English language rights, translation & production by World Book Media, LLC

Illustrators: aque (Megumi Akuzawa), Junko Akino, Asaki Yacai, Chikako Abe, Masako Inoue, amycco. (Emiko), Megumi Ochiai, cotolie, Kaori Takata, Chiko, Terue Fujiwara, macco, miyako, Hiroko Yokoyama, Miki Yonezawa, yuki, & Rieko Wakayama

Editors: Noriaki Sakabe and Kenta Hamaguchi
Design: Ikko Takahashi
Publisher: Akira Naito
Translator: Eri Henderson
English Editor: Lindsay Fair

We have made every effort to ensure the accuracy and completeness of these instructions. We cannot, however, be responsible for human error, typographical mistakes, or variations in individual work.

ISBN: 978-1-940552-50-7

Printed in China

10 9 8 7 6 5 4 3 2 1

DOODLE IT ALL!

BOUTIQUE-SHA

LEARN to DRAW with OVER

1000 CUTE & EASY STEP-BY-STEP ILLUSTRATIONS

CONTENTS

BALLPOINT PEN ILLUSTRATION BASICS

DOODLES

SPECIAL LESSONS

DOODLE INDEX

ABOUT THE ARTISTS

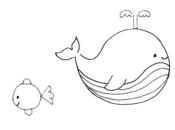

ALL ABOUT BALLPOINT PENS

There are many types of ballpoint pens you can use to doodle. Let's start out by learning all about the different options so you can choose the pen that works best for you!

HOW TO CHOOSE A BALLPOINT PEN

How should you choose which type of ballpoint pen to use for your drawings? If possible, go visit an art supply store and try out the pens they offer. You will find that different brands and different inks create different effects.

The first step in choosing a pen is to decide if you'd like to use single color pens or a multicolor pen. Single color pens come in a variety of shades. It's great to have so many color options, but it can be cumbersome to carry around several pens. With a multicolor pen, you always have a number of different colors on hand, but the pen itself is bulkier. Choose your pens based on the intended use and your lifestyle.

SINGLE COLOR PENS

Choose from retractable pens or pens with caps.

THREE COLOR PEN

Comes with black, red, and blue—a classic color combination.

MULTICOLOR PEN

These pens come with 5 colors, 8 colors, or even 10 colors!

INK TYPE

Ink type makes a big difference in the feel of the pen. The three most common types of ink are: oil-based, water-based, and gel ink.

OIL-BASED INK

Creates long-lasting illustrations. Looks and feels a bit heavier than water-based ink.

WATER-BASED INK

Smooth and light, making it easy to draw, but tends to smudge easily. Available in bright colors.

GEL INK

Combines the best characteristics of oil and water-based inks. Ink is visible in the pen, so you always know how much is left.

PEN THICKNESS

Pen thickness also makes a big difference in the look of the finished drawing. Even if pens are labeled as the same thickness, the line weight can vary from brand to brand.

0.38 MM
Use for fine lines and details within illustrations.

0.5 MM
The most common pen thickness. Available in a wide variety of colors.

0.7 MM
Has a slightly thicker point. Use when you want to draw bold outlines.

1.0 MM
This thick pen is not suitable for details, but is great for filling large areas with color.

SPECIAL EFFECTS

Ballpoint pen technology has advanced greatly—the pens available today often possess special features and you can often use them to draw on materials other than paper. Choose a pen depending on your preferred medium.

ERASABLE PENS

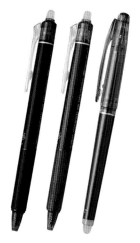

Include rubber erasers on the end. Be careful not to erase too much—it can damage the paper.

MULTISURFACE PENS

Draw on glass, plastic, and metal. Use to draw on bottles, mirrors, and other smooth surfaces.

PHOTO PENS

Use black ink for photos with light backgrounds and bright or pastel ink for photos with dark backgrounds.

INK COLORS

As the popularity of ballpoint pens has increased, new ink colors have been developed. Experiment with different colors to create fun doodles!

FLUORESCENT

Neon colors create eye-catching illustrations.

METALLIC

Shiny colors, such as gold and silver, add an elegant touch.

GLITTER

Sparkly ink creates a feminine impression.

PASTEL

Soft, muted tones combine well with other colors.

PEN REFILLS

Refillable pens are a convenient, eco-friendly option. Choose your favorite ink colors and make your own custom pen.

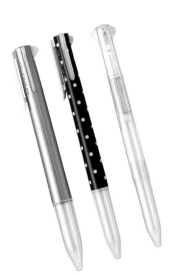

You can purchase refillable pen bodies in both single color and multicolor styles.

Ink refills are also sold separately. Designs vary based on manufacturer and pen type, so check that the refill will work with your pen before purchasing.

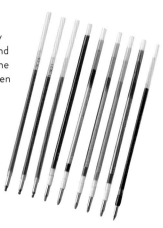

DRAWING MATERIALS

You aren't limited to drawing on paper! In addition to doodling in notebooks and on scrap paper, try drawing on gift bags, personal accessories, and other everyday items.

NOTEBOOKS & DIARIES

Fill the covers and pages of your notebooks and diaries with doodles! Look for notebooks made of paper that doesn't absorb ink—this will prevent bleed through.

LETTER SETS & NOTE CARDS

Decorate blank stationery with fun illustrations to create custom correspondence. Or add doodles to stationery that already has a design.

BAGS

Embellish gift bags and lunch bags with cute doodles. If you have the right pen, you can even draw on transparent plastic bags.

TAGS & STICKY NOTES

Make your notes and messages more fun by adding doodles. Sticky notes are available in unique shapes and sizes.

STORAGE ITEMS

Specialized ballpoint pens allow you draw on objects with smooth surfaces, such as plastic and glass. Try decorating glass jars or plastic cases to help you stay organized.

EVERYDAY OBJECTS

You can even buy blank objects just waiting to be customized. Tumbler cups often come with paper inserts that can be replaced. Or try personalizing a blank phone case.

COLORING WITH BALLPOINT PENS

The way you color your illustrations will have an impact on the finished look, so it's important to consider a couple things before you start drawing. First, which color scheme will you use for your illustration? Changing the color scheme can create a completely different impression, even when drawing the same image. Second, which technique will you use to color your illustration? Choose the method that suits your style and desired use.

COLOR COMBINATIONS

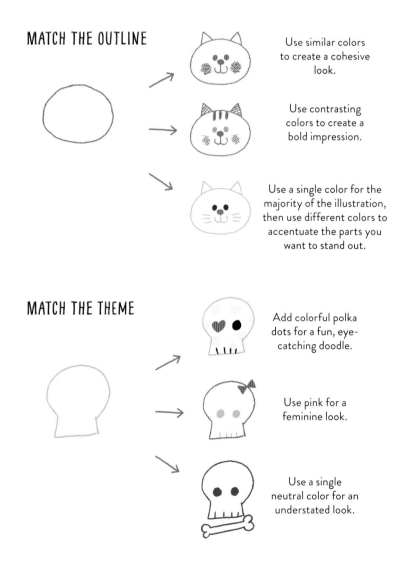

MATCH THE OUTLINE

Use similar colors to create a cohesive look.

Use contrasting colors to create a bold impression.

Use a single color for the majority of the illustration, then use different colors to accentuate the parts you want to stand out.

MATCH THE THEME

Add colorful polka dots for a fun, eye-catching doodle.

Use pink for a feminine look.

Use a single neutral color for an understated look.

COLORING TECHNIQUES

SOLID

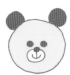

Color inside the lines without leaving any gaps.

ACCENT

Add color only to areas you want to accentuate. This technique can be used to convey emotion.

ROUGH

Color quickly without worrying about gaps.

CIRCULAR

Use a circular motion to add color. This technique is similar to rough coloring.

OVERHANGING

Color slightly outside the lines to create a hand drawn impression.

CONTOUR

Color following the shape of the outlines to create a unique impression.

DIAGONAL

Draw evenly spaced diagonal lines. This technique is actually easier than solid coloring!

CROSSHATCH

Draw crosswise diagonal lines. Space the lines close together for a detailed, precise impression.

ANIMALS

There's no reason to be intimidated to draw animals! Start out by drawing the face using basic shapes, like circles and squares. Once you get the hang of drawing faces, add the rest of the body and try drawing animals in action.

BASIC SHAPES

Let's draw animals based on their face shape.

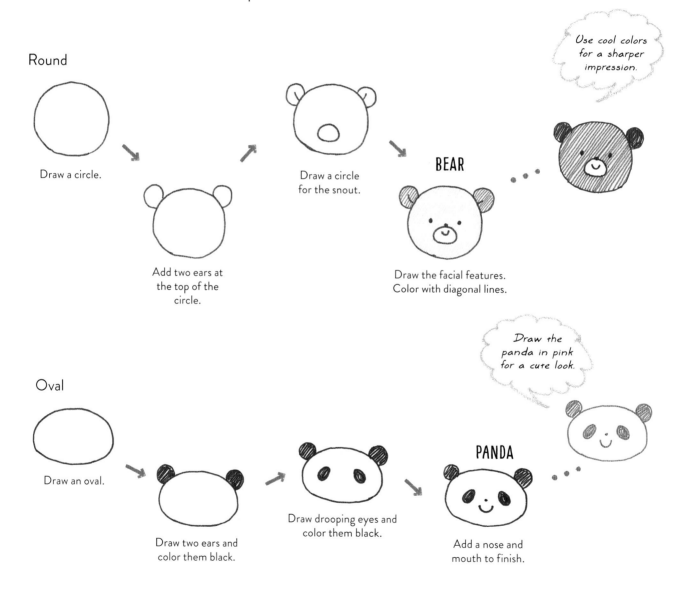

Round

Draw a circle.

Add two ears at the top of the circle.

Draw a circle for the snout.

BEAR

Draw the facial features. Color with diagonal lines.

Use cool colors for a sharper impression.

Oval

Draw an oval.

Draw two ears and color them black.

Draw drooping eyes and color them black.

PANDA

Add a nose and mouth to finish.

Draw the panda in pink for a cute look.

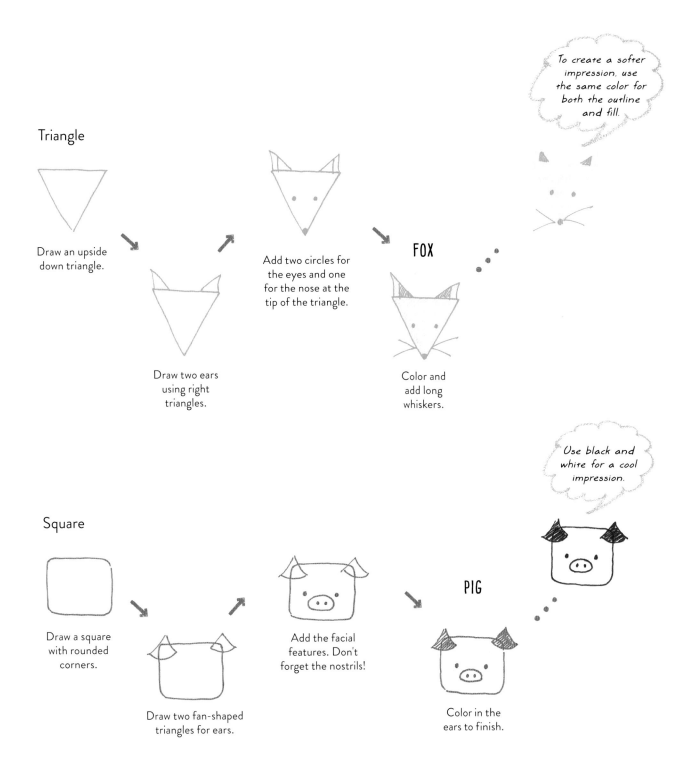

Triangle

Draw an upside down triangle.

Draw two ears using right triangles.

Add two circles for the eyes and one for the nose at the tip of the triangle.

FOX

Color and add long whiskers.

To create a softer impression, use the same color for both the outline and fill.

Square

Draw a square with rounded corners.

Draw two fan-shaped triangles for ears.

Add the facial features. Don't forget the nostrils!

PIG

Color in the ears to finish.

Use black and white for a cool impression.

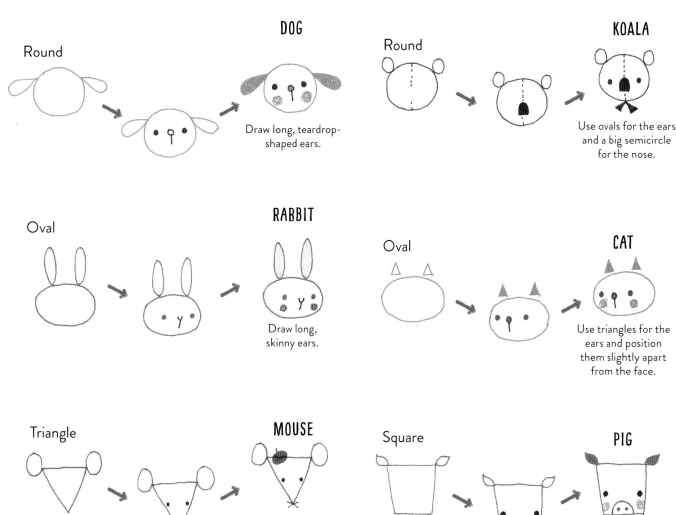

DOG
Round → Draw long, teardrop-shaped ears.

KOALA
Round → Use ovals for the ears and a big semicircle for the nose.

RABBIT
Oval → Draw long, skinny ears.

CAT
Oval → Use triangles for the ears and position them slightly apart from the face.

MOUSE
Triangle → Draw big ears and add a stylish beret.

PIG
Square → Color in the small lemon-shaped ears.

VARIATIONS

Use different line styles to create unique animal faces.

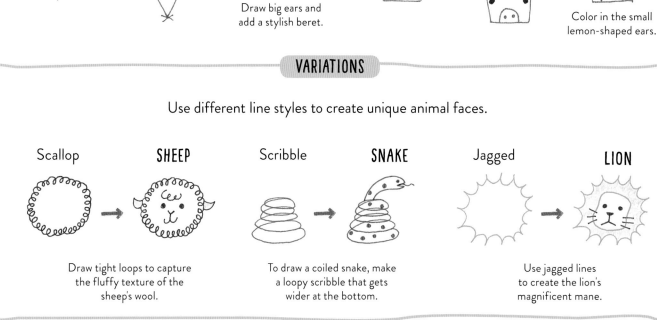

SHEEP
Scallop → Draw tight loops to capture the fluffy texture of the sheep's wool.

SNAKE
Scribble → To draw a coiled snake, make a loopy scribble that gets wider at the bottom.

LION
Jagged → Use jagged lines to create the lion's magnificent mane.

DOG

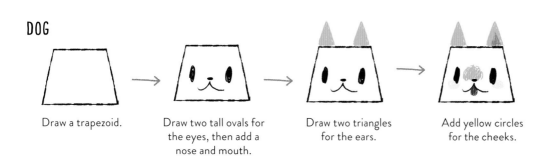

Draw a trapezoid.

Draw two tall ovals for the eyes, then add a nose and mouth.

Draw two triangles for the ears.

Add yellow circles for the cheeks.

For even more cuteness, add a fluffy, wagging tail.

CAT

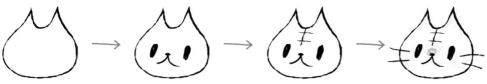

Draw a plump face with sharply pointed ears.

Draw the eyes, nose, and mouth just like the dog shown above.

Draw one vertical line and two horizontal lines on the forehead to create a striped pattern.

Add roughly colored spots to the face.

Use the feet and tail to suggest movement.

RABBIT

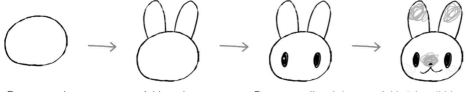

Draw an oval.

Add two long, rounded ears.

Draw two tall ovals in the middle of the face.

Add pink scribbles to the tips of the ears and around the nose.

Use a trapezoid to draw the body quickly and easily.

BEAR

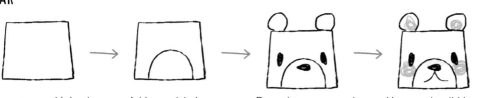

Draw a trapezoid that is almost square.

Add a semicircle at the bottom of the trapezoid.

Draw the eyes spaced far apart to create a gentle expression.

Use round scribbles to add color to the ears and cheeks.

Draw a round, chubby body.

DOGS

FRONT VIEW

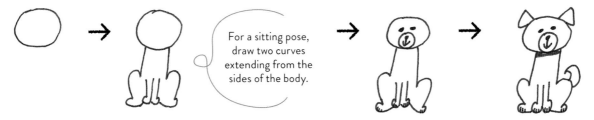

For a sitting pose, draw two curves extending from the sides of the body.

SIDE VIEW

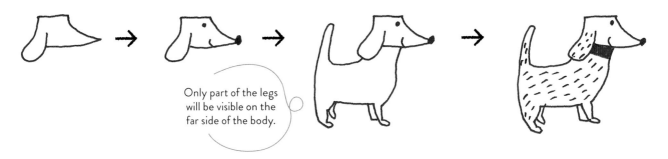

Only part of the legs will be visible on the far side of the body.

SITTING

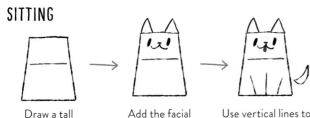

Draw a tall trapezoid, then add a horizontal line for the collar to separate the face and body.

Add the facial features and ears.

Use vertical lines to draw the legs.

SHAKE

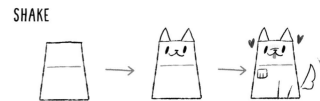

Draw a tall trapezoid, just like for the sitting pose.

Add the facial features and ears.

Draw one raised paw just under the collar and use vertical lines for the other front leg.

BELLY RUB

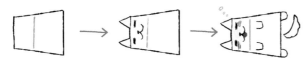

Draw a sideways trapezoid and add a line for the collar.

Use two lines to draw closed eyes and create a relaxed expression.

Use red to add color to the cheeks and express the dog's happiness.

DOG ACTIONS

You can draw different gestures just by changing the angle of the neck and body slightly.

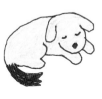

SLEEPING

JUMPING

EATING

STANDING

DOG BREEDS

You can draw different types of dogs by changing the hair texture.

SHIBA INU

Use slanted ovals to draw sharp eyes.

POODLE

Use curly lines to draw fluffy fur on top of the head.

CHIHUAHUA

Draw big ears and use tall ovals for the eyes.

CORGI

Draw a friendly, gentle facial expression.

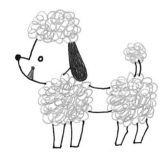

It's easy to draw poodle fur—just make loopy scribbles!

SHIBA INU

CHIHUAHUA

TOY POODLE

CATS

FRONT VIEW

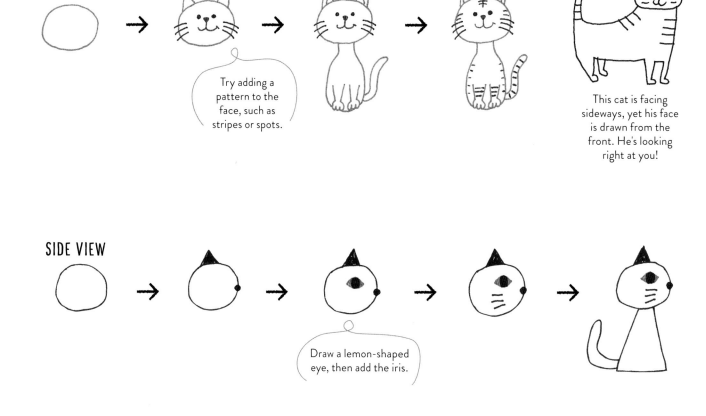

Try adding a pattern to the face, such as stripes or spots.

This cat is facing sideways, yet his face is drawn from the front. He's looking right at you!

SIDE VIEW

Draw a lemon-shaped eye, then add the iris.

Add a bow around the neck.

Draw the front paws together for a well-mannered cat.

Add a ball of yarn or a toy for a playful pose.

DOWN

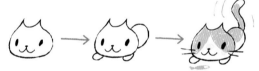

Position the facial features on the lower half of the face.

Draw the front paws beneath the face and draw the body with the hips pointing up.

Draw a slightly bent tail.

STRETCHING

Draw an oval with a slightly diagonal slant.

Draw a curved body that extends up at the back.

Draw short lines for claws at the tips of the paws.

RUNNING

Position the facial features on the right half of the face.

Draw the body beneath the face.

Draw the front legs outstretched and the back legs extended.

Add some vertical lines beneath the body to show speed and action.

VARIATIONS

CAT POSES

Try some classic cat poses, such as sitting, hissing, and pawing.

CAT BREEDS

You can draw different types of cats just by changing the patterns and length of the fur—try spots and stripes, short hair and long hair.

CALICO

Use orange and black to add large patches of color to the face.

TABBY

Draw a striped pattern down the middle of the face.

PERSIAN

Draw the characteristic slanted green eyes.

MORE ANIMALS

Use the same basic principles to draw a variety of animals from the jungle, forest, and farm.

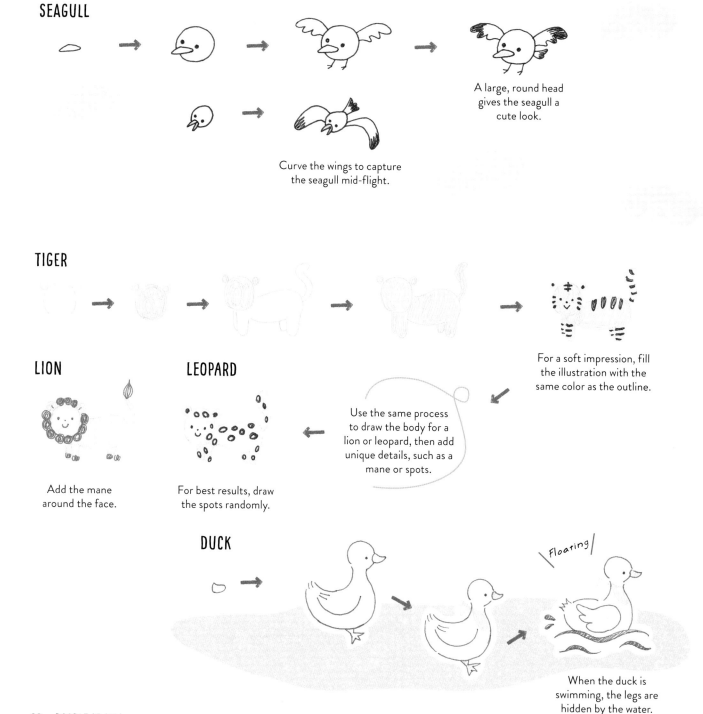

SEAGULL

A large, round head gives the seagull a cute look.

Curve the wings to capture the seagull mid-flight.

TIGER

For a soft impression, fill the illustration with the same color as the outline.

LION

Add the mane around the face.

LEOPARD

For best results, draw the spots randomly.

Use the same process to draw the body for a lion or leopard, then add unique details, such as a mane or spots.

DUCK

Floating

When the duck is swimming, the legs are hidden by the water.

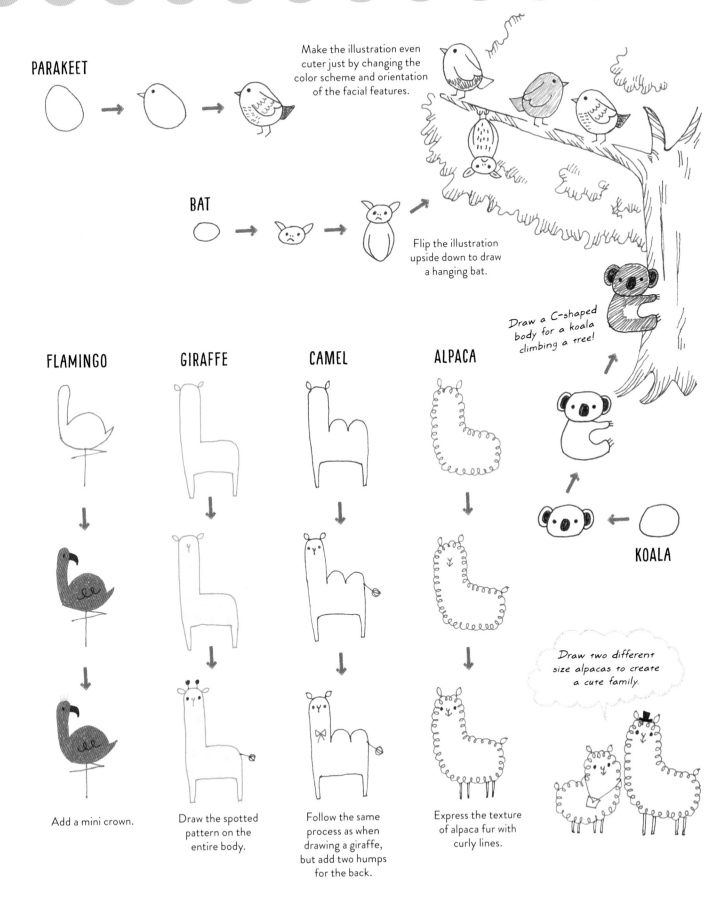

PARAKEET

Make the illustration even cuter just by changing the color scheme and orientation of the facial features.

BAT

Flip the illustration upside down to draw a hanging bat.

Draw a C-shaped body for a koala climbing a tree!

FLAMINGO

Add a mini crown.

GIRAFFE

Draw the spotted pattern on the entire body.

CAMEL

Follow the same process as when drawing a giraffe, but add two humps for the back.

ALPACA

Express the texture of alpaca fur with curly lines.

KOALA

Draw two different size alpacas to create a cute family.

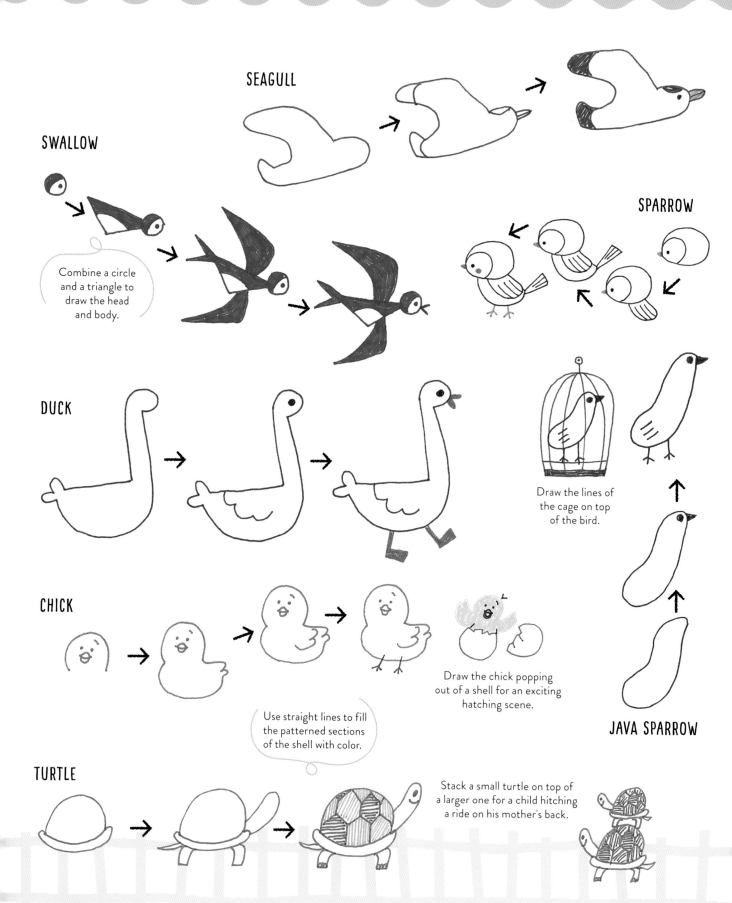

SEAGULL

SWALLOW

Combine a circle and a triangle to draw the head and body.

SPARROW

DUCK

Draw the lines of the cage on top of the bird.

CHICK

Draw the chick popping out of a shell for an exciting hatching scene.

Use straight lines to fill the patterned sections of the shell with color.

JAVA SPARROW

TURTLE

Stack a small turtle on top of a larger one for a child hitching a ride on his mother's back.

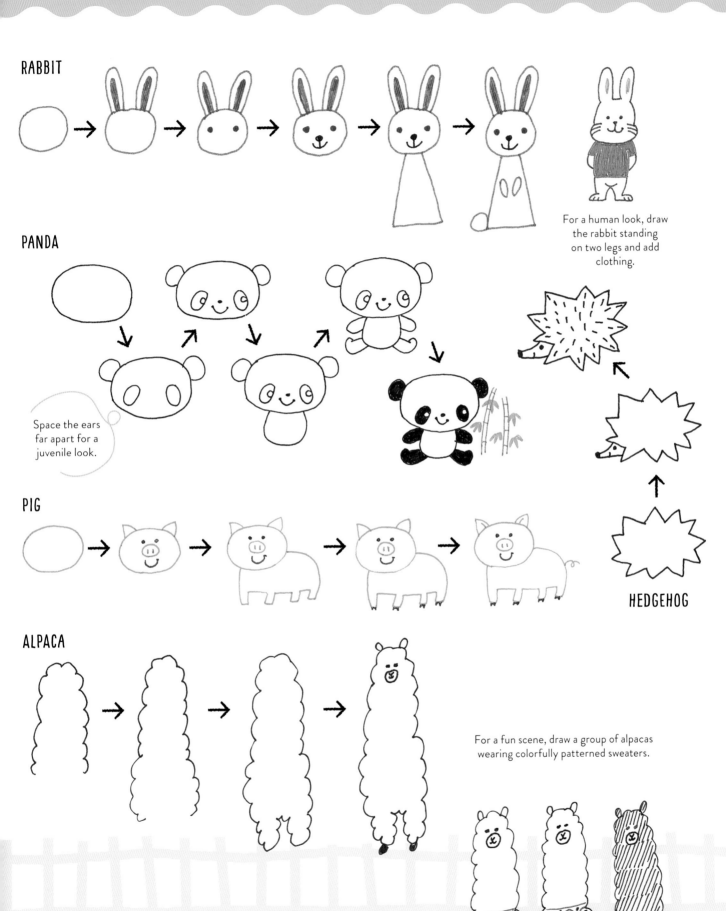

RABBIT

For a human look, draw the rabbit standing on two legs and add clothing.

PANDA

Space the ears far apart for a juvenile look.

PIG

HEDGEHOG

ALPACA

For a fun scene, draw a group of alpacas wearing colorfully patterned sweaters.

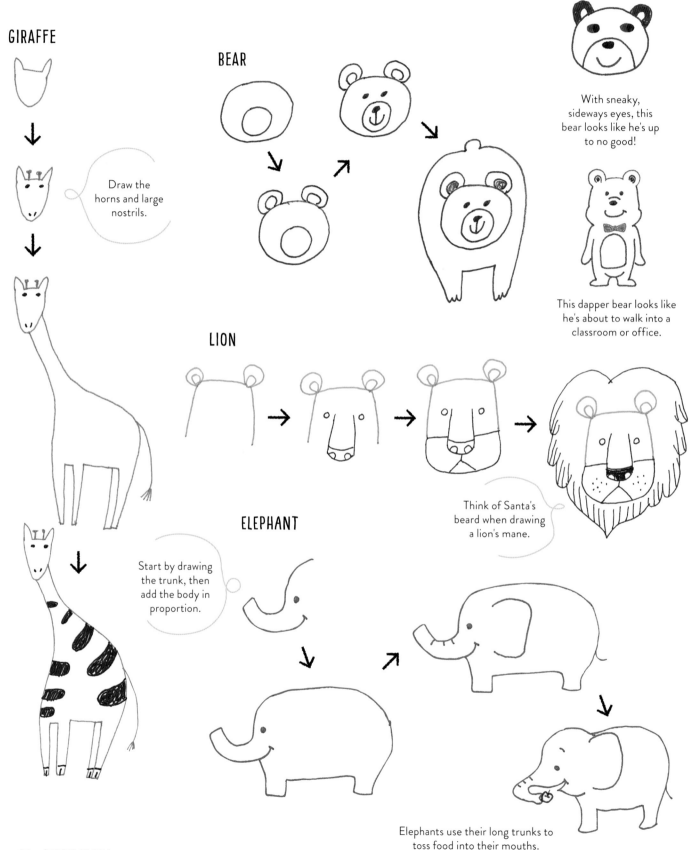

GIRAFFE

Draw the horns and large nostrils.

BEAR

With sneaky, sideways eyes, this bear looks like he's up to no good!

This dapper bear looks like he's about to walk into a classroom or office.

LION

Think of Santa's beard when drawing a lion's mane.

ELEPHANT

Start by drawing the trunk, then add the body in proportion.

Elephants use their long trunks to toss food into their mouths.

You can use the same basic shapes to draw various animals. Use color and pattern to capture the distinct features of each animal.

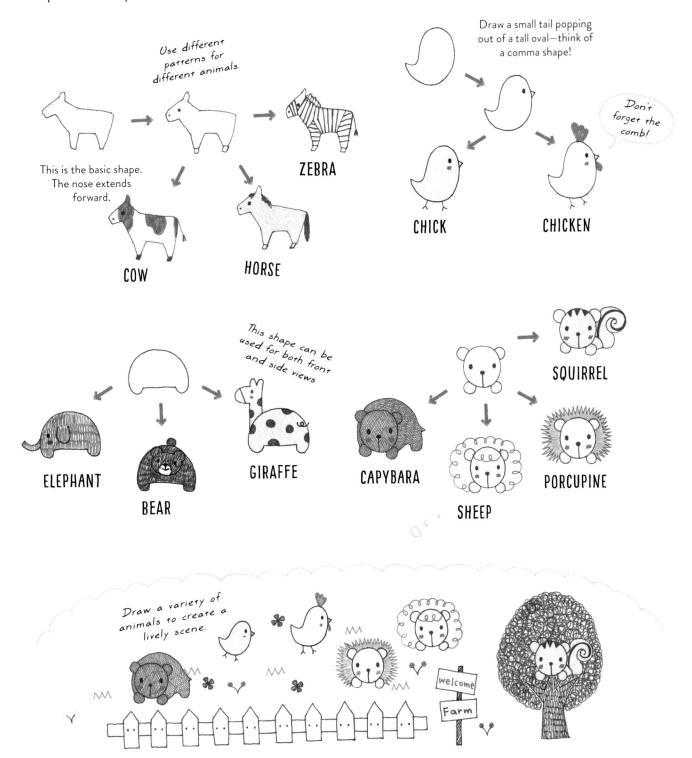

Use different patterns for different animals.

This is the basic shape. The nose extends forward.

ZEBRA

COW

HORSE

Draw a small tail popping out of a tall oval—think of a comma shape!

Don't forget the comb!

CHICK

CHICKEN

This shape can be used for both front and side views

ELEPHANT

BEAR

GIRAFFE

CAPYBARA

SQUIRREL

SHEEP

PORCUPINE

Draw a variety of animals to create a lively scene.

welcome

Farm

AQUATIC ANIMALS

These illustrations feature animals who spend most of their time in or around water. The ocean is one of the most diverse habitats on earth, so have fun drawing a variety of unique creatures!

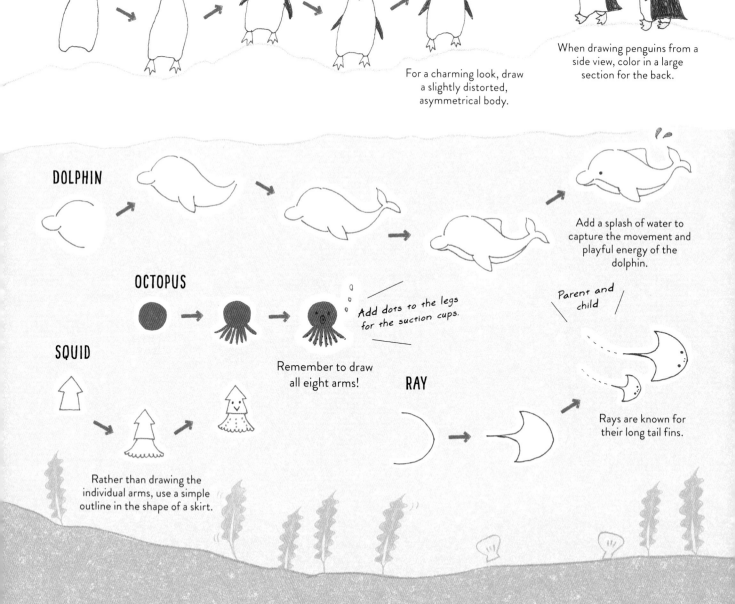

PENGUIN

For a charming look, draw a slightly distorted, asymmetrical body.

When drawing penguins from a side view, color in a large section for the back.

DOLPHIN

Add a splash of water to capture the movement and playful energy of the dolphin.

OCTOPUS

Add dots to the legs for the suction cups.

Remember to draw all eight arms!

SQUID

Rather than drawing the individual arms, use a simple outline in the shape of a skirt.

RAY

Parent and child

Rays are known for their long tail fins.

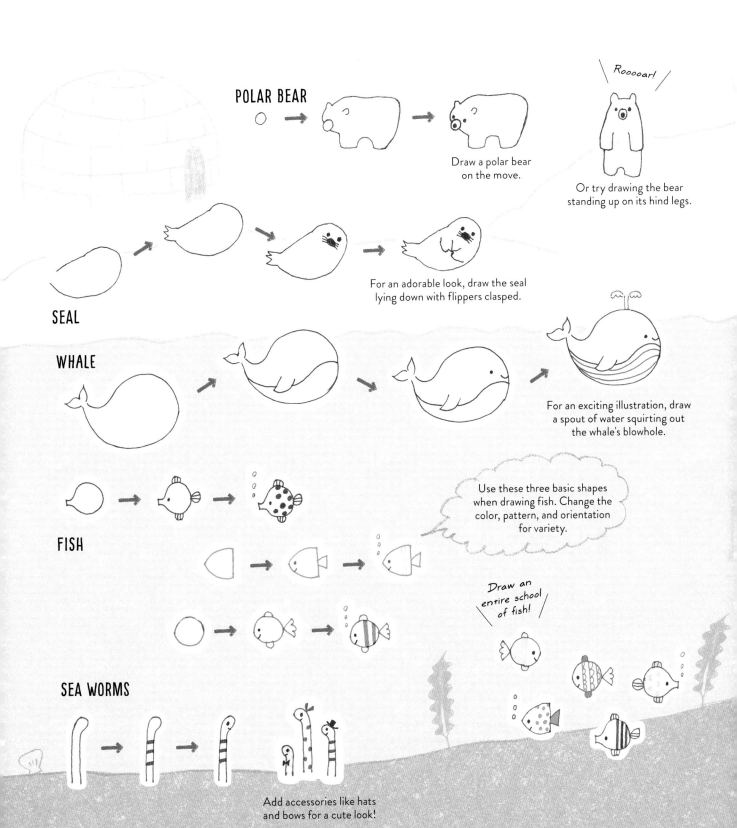

POLAR BEAR

Draw a polar bear on the move.

Rooooar!

Or try drawing the bear standing up on its hind legs.

SEAL

For an adorable look, draw the seal lying down with flippers clasped.

WHALE

For an exciting illustration, draw a spout of water squirting out the whale's blowhole.

FISH

Use these three basic shapes when drawing fish. Change the color, pattern, and orientation for variety.

Draw an entire school of fish!

SEA WORMS

Add accessories like hats and bows for a cute look!

FISH

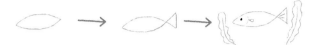

Draw a long almond shape.

Add a triangle to the end.

Add an eye and a fin. You can even add some seaweed for a bit of scenery.

JELLYFISH

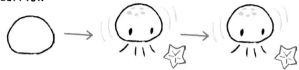

Draw a circle that is wider at the bottom.

Draw the eyes at the bottom of the circle, then add four lines underneath for the tentacles.

Add blue lines to show that the jellyfish is floating in the water.

TROPICAL FISH

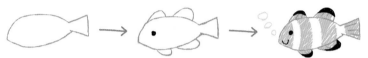

Draw the body and tail fin together.

Add some rounded fins.

Use bright colors to fill the body with interesting patterns.

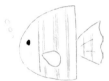

Try drawing a long, slender body for a stylish look.

Add color to the cheek for a cute touch.

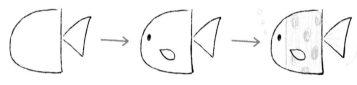

Draw a semicircle then add a triangle to the end.

Add an eye and teardrop-shaped fin.

Add some lines to the tail fin.

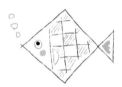

Use triangles for a classically-shaped tropical fish.

Don't be afraid to experiment with unique patterns and color combinations.

OCTOPUS

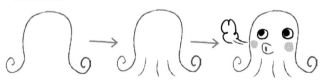

Draw an upside down U shape that curls at the ends.

Add some curved lines to the bottom.

Draw the mouth extending out from the face and add a burst of ink.

SQUID

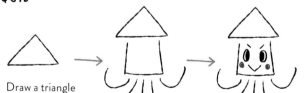

Draw a triangle that's wider at the bottom.

Add a square underneath, then draw lines for the tentacles. Make some of the legs curved.

Eyebrows add a cute, quirky touch.

DOLPHIN

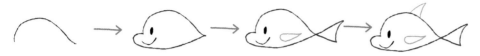

Draw a gentle curve that is higher on the left side.

Draw the nose extending from the face.

Make the tail fin a little longer than on a fish.

Add a sharply pointed back fin.

WHALE

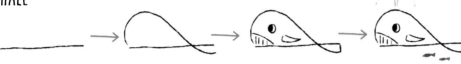

Draw a straight line.

Draw a sweeping curve above the straight line. This will make the body look like it's popping out of the water.

Add some lines for the mouth.

Draw water spouting out of the whale's blowhole.

SHARK

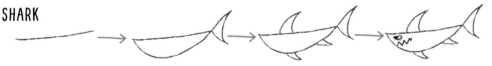

Draw a straight line.

Draw a curve beneath the straight line to complete the semicircle, then add a triangular tail fin.

Draw sharply pointed fins.

Use a jagged line to draw sharp teeth.

OTTER

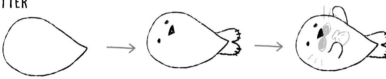

Draw a slightly uneven teardrop shape.

Draw a triangular nose.

Draw the otter clasping a shell.

SEAL

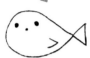

Draw a slightly uneven teardrop shape.

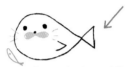

Add two small eyes.

Draw a horizontal figure eight for the mouth and add whiskers.

PENGUIN

Draw a tall semicircle.

Add an oval for the beak and semicircles for the feet.

Color in the beak and draw diagonal lines to separate the flippers from the body.

SEAWEED

Start by drawing a few gently curved lines, then surround each one with a wavy line.

CORAL

Use red or pink to draw a miniature tree shape.

STARFISH

Draw a large star, then add dots to capture the texture.

SHELLFISH

Start with a circle, then add a small rectangle at the bottom. Add diagonal lines to the circle.

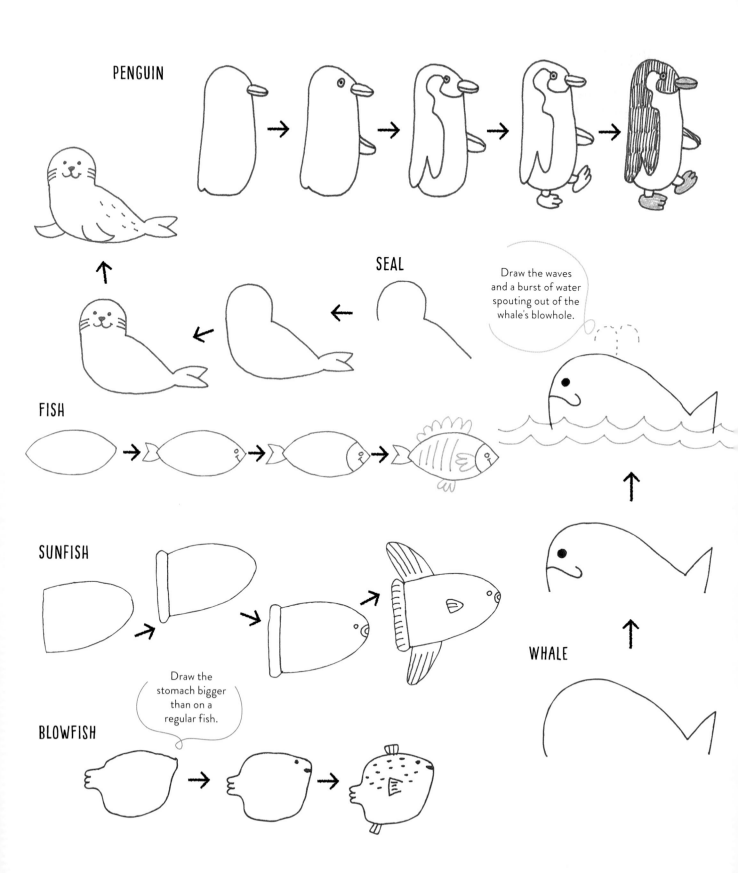

PENGUIN

SEAL

Draw the waves and a burst of water spouting out of the whale's blowhole.

FISH

SUNFISH

Draw the stomach bigger than on a regular fish.

BLOWFISH

WHALE

BUGS & INSECTS

Bugs are known for their bright colors and unique markings, such as stripes and dots. Just like when drawing other animals, start with basic shapes and then add the details.

LADYBUG

| Draw a circle. | Draw the dots symmetrically. | Leave a white triangle at the center to show that the wings are spread apart. | The body becomes a semicircle when viewed from the side. | Change it up! Use unique shapes and colors for the pattern. | For a cute twist, draw hearts instead of spots. |

BUTTERFLY

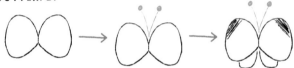

| Connect two rounded triangles. | Draw small circles at the tips of the antennae. | Color the upper tips of the wings black. | Use purple and black for a chic color combination. | Only one wing is visible when the butterfly is drawn from a side view. | You can also use heart shapes for the wings. |

HONEYBEE

 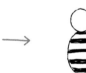 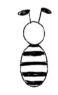 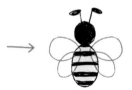

| Connect a circle and an oval. | Add 4-5 thick black lines to the oval. | Add antennae that look like upside down legs. | Color the body yellow and add transparent wings. | Skip the outline! Draw a yellow body and add black stripes and wings. |

DRAGONFLY

 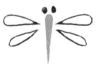

| Draw a diagonal line. | Draw two oval eyes at the end of the line. | Add four symmetrical teardrop-shaped wings. | Try coloring the body brown for a more neutral design. |

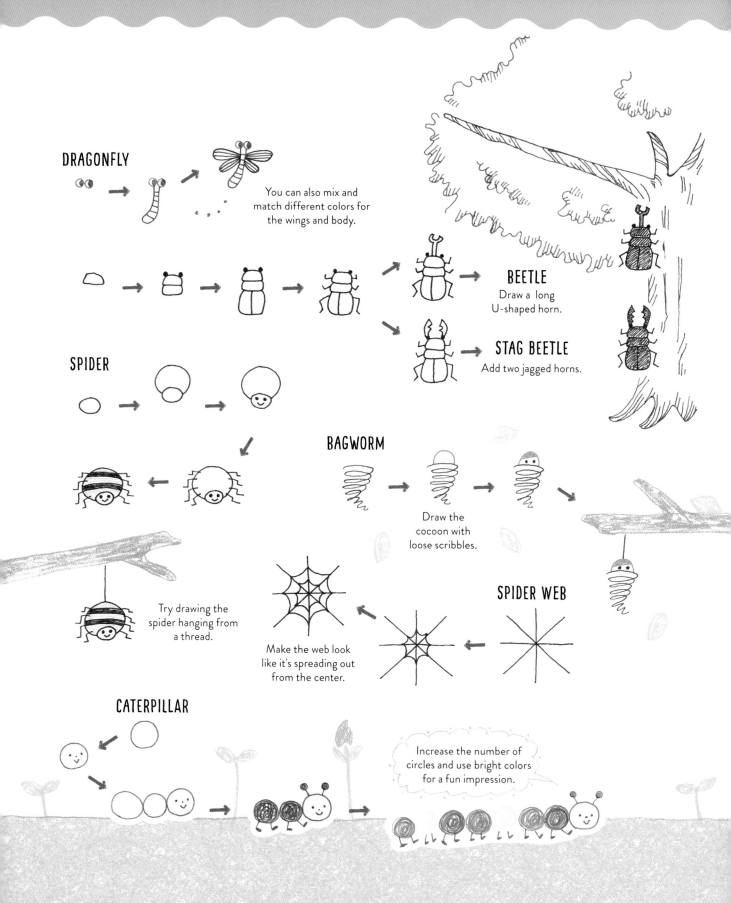

DRAGONFLY

You can also mix and match different colors for the wings and body.

BEETLE
Draw a long U-shaped horn.

STAG BEETLE
Add two jagged horns.

SPIDER

BAGWORM

Draw the cocoon with loose scribbles.

Try drawing the spider hanging from a thread.

SPIDER WEB

Make the web look like it's spreading out from the center.

CATERPILLAR

Increase the number of circles and use bright colors for a fun impression.

BUTTERFLY (SIDE VIEW)

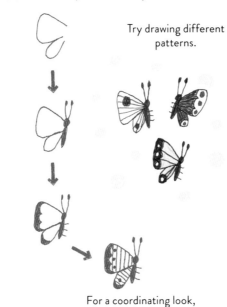

Try drawing different patterns.

For a coordinating look, use similar colors for the different components.

BUTTERFLY (FRONT VIEW)

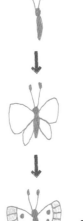

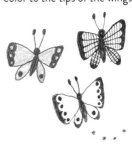

For a more realistic look, add color to the tips of the wings.

Start at the center and then add wings in proportion to the body.

LADYBUG

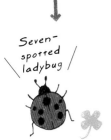

Seven-spotted ladybug

Combine a semicircle and a circle to make a cute round shape.

SNAIL

Draw a spiral for the shell.

Try changing the color or direction.

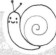
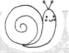

BEE

Don't forget the stinger!

ANT

Use the same body shape as for the bee, but add another circle to the end.

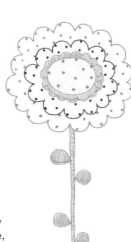

PEOPLE

Let's practice drawing people based on gender and age. Once you master various expressions and gestures, you can combine them to create countless illustrations.

GIRLS

A round face is the easiest shape to draw. Plus, a round face creates a cute, friendly look!

Don't forget the smile!

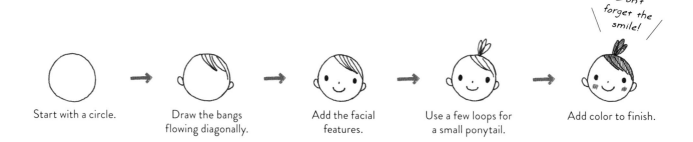

| Start with a circle. | Draw the bangs flowing diagonally. | Add the facial features. | Use a few loops for a small ponytail. | Add color to finish. |

BOYS

Draw the faces slightly longer than when drawing girls.

Try different hair colors!

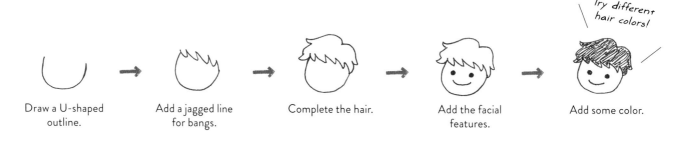

| Draw a U-shaped outline. | Add a jagged line for bangs. | Complete the hair. | Add the facial features. | Add some color. |

VARIATIONS

VARIOUS HAIRSTYLES

| Parted | Mohawk | Afro | Shaggy | Spiky |

DRAWING FACES FROM DIFFERENT ANGLES

It's easy to draw faces from different angles when you use guidelines! Use a pencil to draw guidelines to help you determine the placement of the facial features. Don't forget to erase them when you're done!

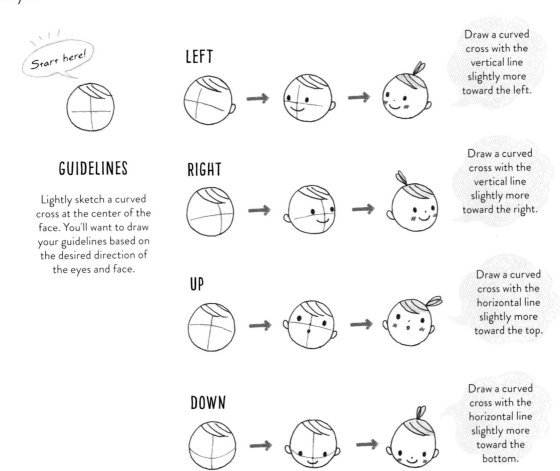

Start here!

GUIDELINES

Lightly sketch a curved cross at the center of the face. You'll want to draw your guidelines based on the desired direction of the eyes and face.

LEFT

Draw a curved cross with the vertical line slightly more toward the left.

RIGHT

Draw a curved cross with the vertical line slightly more toward the right.

UP

Draw a curved cross with the horizontal line slightly more toward the top.

DOWN

Draw a curved cross with the horizontal line slightly more toward the bottom.

VARIATIONS

FACIAL EXPRESSIONS

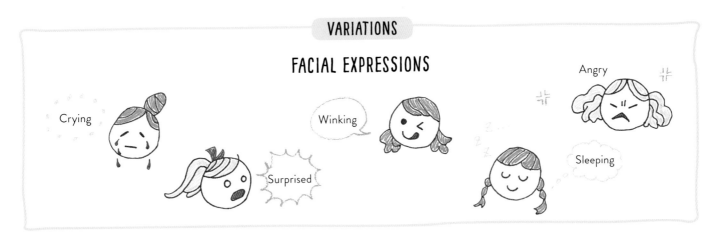

Crying

Surprised

Winking

Angry

Sleeping

BABIES

Keep it simple when drawing babies—start with a round face, then add a few details.

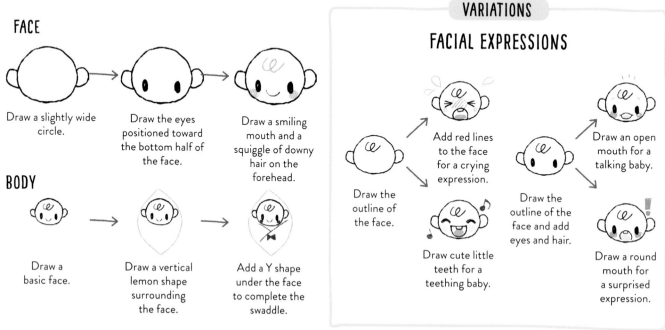

FACE

Draw a slightly wide circle.

Draw the eyes positioned toward the bottom half of the face.

Draw a smiling mouth and a squiggle of downy hair on the forehead.

BODY

Draw a basic face.

Draw a vertical lemon shape surrounding the face.

Add a Y shape under the face to complete the swaddle.

VARIATIONS

FACIAL EXPRESSIONS

Draw the outline of the face.

Add red lines to the face for a crying expression.

Draw cute little teeth for a teething baby.

Draw the outline of the face and add eyes and hair.

Draw an open mouth for a talking baby.

Draw a round mouth for a surprised expression.

VARIATIONS

HAIRSTYLES

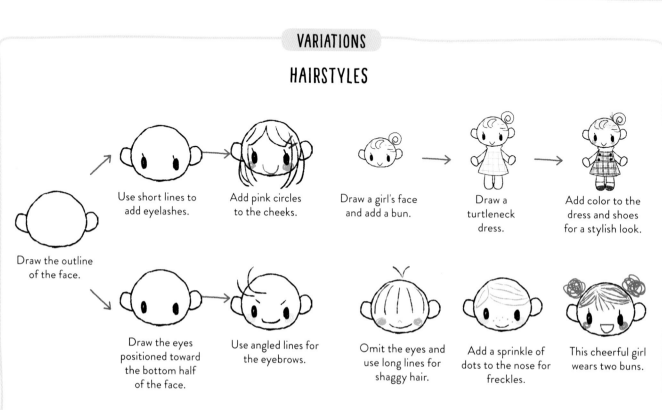

Draw the outline of the face.

Use short lines to add eyelashes.

Add pink circles to the cheeks.

Draw a girl's face and add a bun.

Draw a turtleneck dress.

Add color to the dress and shoes for a stylish look.

Draw the eyes positioned toward the bottom half of the face.

Use angled lines for the eyebrows.

Omit the eyes and use long lines for shaggy hair.

Add a sprinkle of dots to the nose for freckles.

This cheerful girl wears two buns.

GRANDPARENTS

Use wrinkles and laugh lines to show age.

GRANDMA

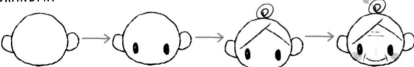

Draw a slightly wide circle. Add ears on the left and right.

Draw the eyes positioned toward the bottom half of the face.

Draw an upside down Y shape for the bangs.

Add wrinkle lines to the corners of the mouth and the forehead.

Draw a laughing mouth and eyes for a warm, loving grandma.

Change the position of the wrinkle lines based on the expression.

GRANDPA

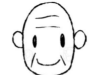

Draw a tall oval.

Draw the eyes and ears in the middle of the face.

Add some wrinkles.

Draw a cheerful grandpa with a big, smiling mouth.

Close one eye in a wink for a joking grandpa.

BODY

Draw the face.

Use a gentle curve to draw a slightly bent back.

Draw four circles for the hands and feet.

Color her clothes and add a cane.

Draw grandma relaxing with a cup of tea.

VARIATIONS

HAIRSTYLES

SIDE PART

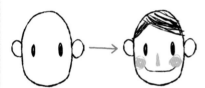

Draw the face.

Draw the hair coming from one side of the head for a dad-inspired style.

COMB OVER

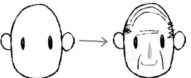

Draw the face.

Use curved lines to draw thin strands of hair along the top of the head.

PONYTAIL

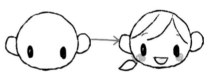

Draw the face.

Draw the hair pulled back off the face for a mom hairstyle.

PORTRAITS

When drawing a specific person, exaggerate their characteristic features to capture the likeness.

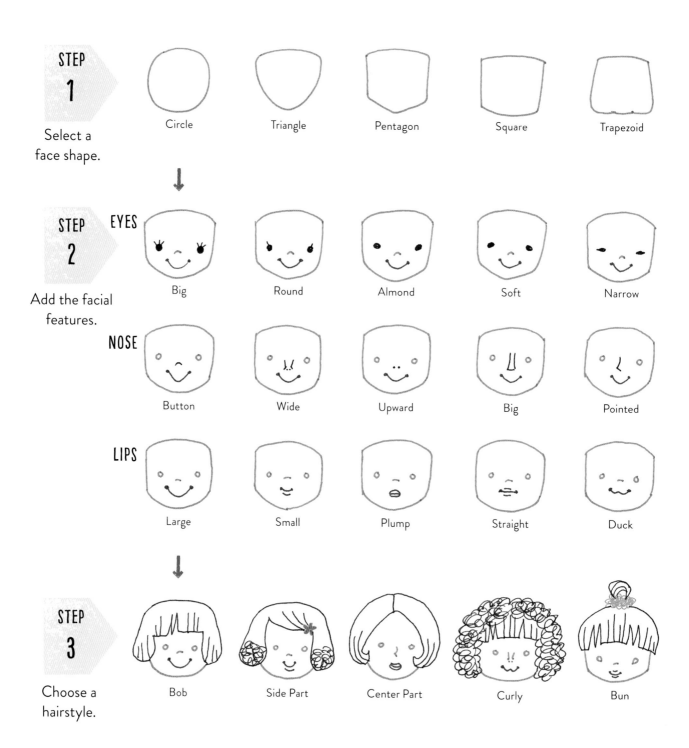

STEP 1 — Select a face shape.

Circle · Triangle · Pentagon · Square · Trapezoid

STEP 2 — Add the facial features.

EYES: Big · Round · Almond · Soft · Narrow

NOSE: Button · Wide · Upward · Big · Pointed

LIPS: Large · Small · Plump · Straight · Duck

STEP 3 — Choose a hairstyle.

Bob · Side Part · Center Part · Curly · Bun

FACIAL EXPRESSIONS

HAPPY

SURPRISED
Draw the hair
standing on end.

SMILING
Show the smile
with both the
eyes and mouth.

EXCITED
Use wavy lines to
express excitement.

DELIGHTED
Draw a wide open
mouth.

SAD
Draw a sad mouth
and a teardrop.

SLEEPY
Draw a drop of drool.

CONFUSED
Draw white circles for the
eyes and an open mouth.

JOKING
Draw the tongue
sticking out for a
playful expression.

SAD **FUNNY**

SHOCKED
Combine elements
of sadness and
anger to create
a shocked
expression.

PANICKED
Drops of sweat
indicate anxiety.

SCARED
Use jagged lines to
express the panic.

NERVOUS
Draw angled
eyebrows and a
drop of sweat.

TROUBLED
Lower one of the
eyebrows and draw
a spiral above the
head to express
worry.

MAD
Draw a cloud of smoke
above the head and use
angular lines for the
eyebrows and mouth.

TIRED
Draw droopy
eyebrows and a
downward gaze.

DISCOURAGED
Use curved lines to
draw sunken cheeks.

ANGRY

BODIES

Many new artists are intimidated by drawing bodies, but it's easy once you learn the basics! Simply change the clothing and hairstyle to draw a variety of different women.

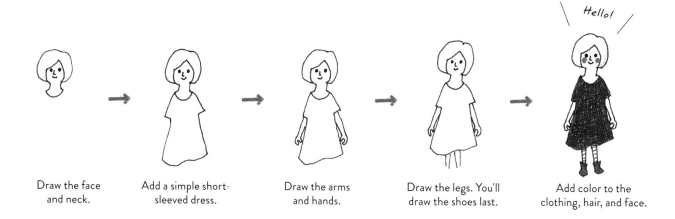

Draw the face and neck.

Add a simple short-sleeved dress.

Draw the arms and hands.

Draw the legs. You'll draw the shoes last.

Add color to the clothing, hair, and face.

Hello!

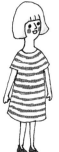

STRIPES
Draw curved stripes that contour to the body.

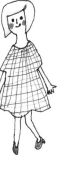

PLAID
Use two or three colors to produce the plaid effect.

POLKA DOTS
Coordinating boots are the height of fashion on a rainy day.

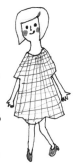

SHIRT DRESS
Add a collar, buttons, and a pocket to create this dress style.

Use bright colors for an energetic look.

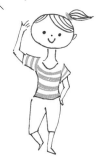

SPORTY
Coordinate the color of her hair scrunchie and the striped shirt.

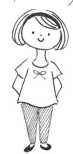

Use cool colors for a relaxed impression.

CASUAL
A headband complements her cute bob hairstyle. The pants are colored in blue to look like jeans.

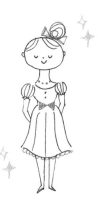

ELEGANT
For a more formal look, draw a dress decorated with ribbons and puffy sleeves.

ACTIONS

Think about the position of the arms and legs when drawing people on the move.

WALKING

 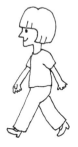

Draw a side view of the face and hair.

Draw the upper body. Draw the right hand extending forward.

Draw the left leg first. Draw the feet partially lifted off the ground.

Add your favorite patterns to the clothes to complete.

RUNNING

Express the speed of the movement by drawing the body bent slightly forward and extend one leg.

SITTING

For an easy-to-draw sitting pose, tuck the knees under the body.

Draw a long dress to hide the feet.

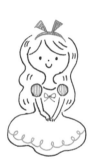

Add puff sleeves and a bow for a cute look.

LYING DOWN

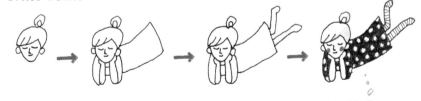

Draw the hands propping up the face for a relaxed look.

STANDING

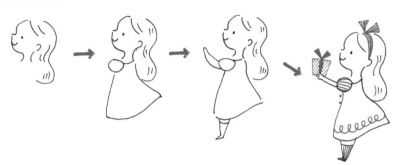

Consider how the movement will affect the body and clothing.

WALKING

The lines of the body help illustrate perspective—one arm is in the front and the other is in the back.

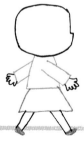
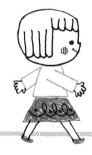

RUNNING

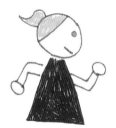
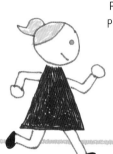

For a skipping pose, bend the legs slightly and elevate the feet off the ground.

SITTING

When he's sitting on the floor, his legs are stretched out straight.

LYING DOWN

For a relaxed look, draw her lying on her side with her head propped up by her hand.

BOWING

Keep the hands in front and the eyes looking down.

GIVING

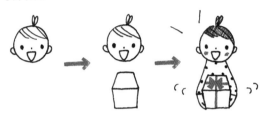

Make the box three-dimensional to show perspective.

POUTING

Lift the elbows up and draw the eyes toward the bottom of the face.

WAVING

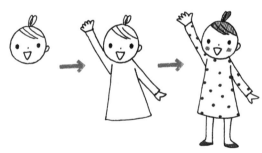

Add an effect line to show movement.

ANGRY

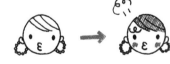

Add a puff of steam and red marks on the face.

TURNING AROUND

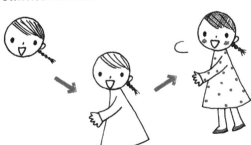

Draw the arm first. This pose is easier to draw with simple clothing, such as a dress.

FOOD

With its bright colors and unique shapes, food is a lot of fun to draw. Use these fun doodles to add excitement to a shopping list, lunch bag, or menu.

FRUIT

Draw rough outlines to sketch out the basic shape, then use different colors of pen to add subtle shading.

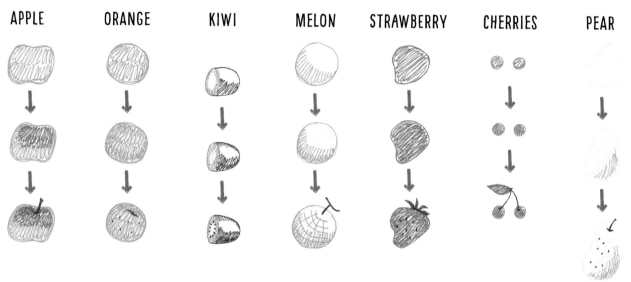

APPLE ORANGE KIWI MELON STRAWBERRY CHERRIES PEAR

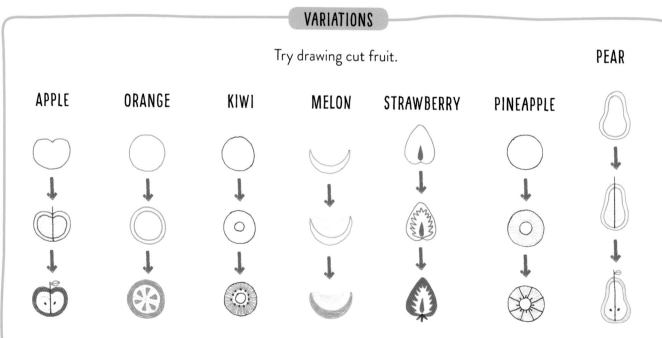

VARIATIONS

Try drawing cut fruit.

APPLE ORANGE KIWI MELON STRAWBERRY PINEAPPLE PEAR

VEGETABLES

Keep the main characteristics of each vegetable in mind as you draw.

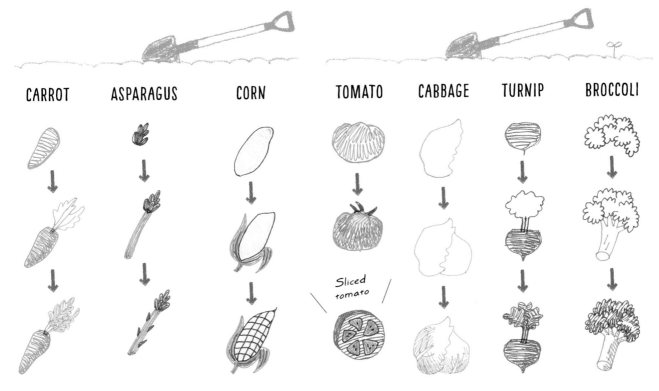

CARROT ASPARAGUS CORN TOMATO CABBAGE TURNIP BROCCOLI

Sliced tomato

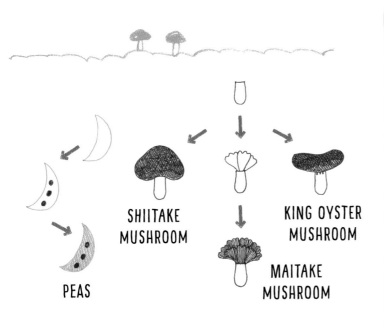

PEAS

SHIITAKE MUSHROOM

MAITAKE MUSHROOM

KING OYSTER MUSHROOM

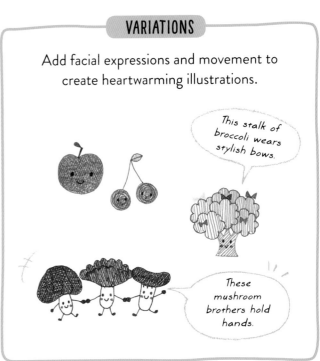

VARIATIONS

Add facial expressions and movement to create heartwarming illustrations.

This stalk of broccoli wears stylish bows.

These mushroom brothers hold hands.

FAVORITE FOODS

From sandwiches and sushi to spaghetti and steak, these are some of our favorite foods to eat and to draw.

RICE

Draw a semicircle with a small rectangle underneath.

Draw a mound of rice shaped like a cloud.

Add short lines or small ovals to represent vegetables and spices.

BREAD

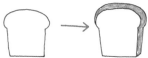

Draw a square with a rounded, wide top.

Add an outline to create a three-dimensional effect.

Add a blob of jam or draw crosshatches to represent burn marks.

OMELET RICE

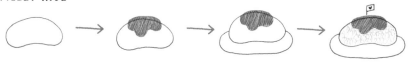 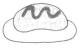 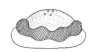

Draw a bean shape.

Add a blob of ketchup on top.

Add a plate underneath.

Color the omelet and garnish with a flag.

Try a squiggle of ketchup instead.

Add some sauce to the omelet.

SANDWICH

Draw a right triangle.

Add lines to create depth.

Add a colorful filling, such as jam.

Try a yellow filling for an egg salad sandwich.

Add colorful vegetables, such as lettuce and tomato.

SPAGHETTI

Start with a red blob for the tomato sauce.

Draw the spaghetti in a figure eight shape.

Add a plate underneath.

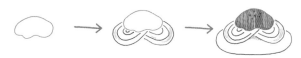 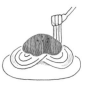

Draw some strands of spaghetti dangling from a fork.

Use a cream color for spaghetti carbonara.

Try topping with cherry tomatoes and basil.

STEAK

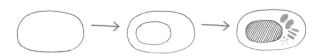

Draw a horizontal oval for the plate.

Add a smaller oval for the meat.

Add colorful vegetables.

STEW

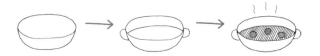

Draw a bowl.

Add a line about halfway up the bowl for the liquid.

Add large, colorful chunks for meat and vegetables.

GRILLED FISH

Draw a rectangle for the serving plate.

Draw the fish and add a cross for grill marks.

Garnish with citrus.

SALAD

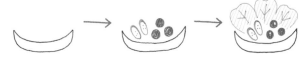

Draw a crescent for the salad bowl.

Fill the bowl with chopped vegetables.

Fill the background in with lettuce leaves.

RICE BALLS

Add a black square for the nori seaweed.

Use a simple red circle for pickled plum.

Draw a crosshatch for a grilled rice ball.

SUSHI

Use fluffy lines when drawing the sushi rice.

Use heart shapes to draw the shrimp.

Draw a long strip of nori for egg sushi.

BREAD

Use triangles for score lines when drawing a baguette.

Draw a symmetrical croissant.

When drawing a cornet, think of a spiral that grows thinner at the top.

BEER

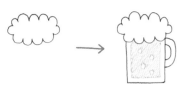

Draw a cloud shape for the foam.

Leave white circles to represent the carbonation.

WINE

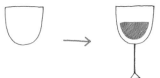

Start with a semicircle.

Leave a bit of white space to depict the thickness of the glass.

COCKTAIL

Draw an upside down triangle.

Garnish with a cherry.

DESSERTS & DRINKS

With their bright colors and unique shapes, desserts and drinks are fun to draw!

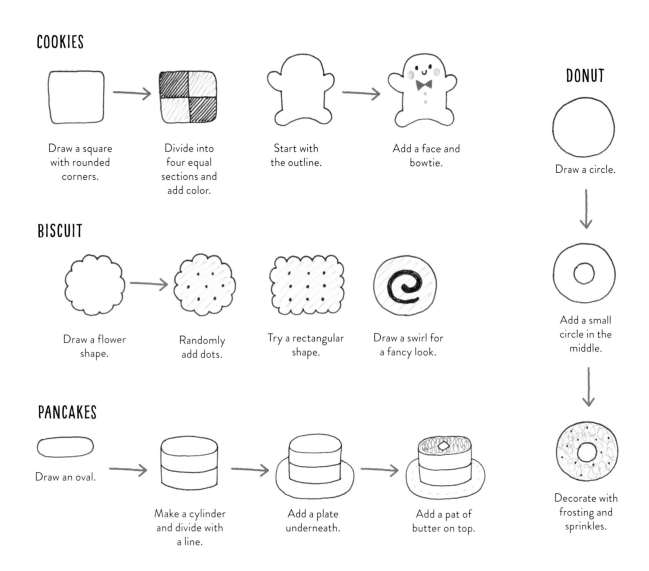

COOKIES

Draw a square with rounded corners.

Divide into four equal sections and add color.

Start with the outline.

Add a face and bowtie.

BISCUIT

Draw a flower shape.

Randomly add dots.

Try a rectangular shape.

Draw a swirl for a fancy look.

PANCAKES

Draw an oval.

Make a cylinder and divide with a line.

Add a plate underneath.

Add a pat of butter on top.

DONUT

Draw a circle.

Add a small circle in the middle.

Decorate with frosting and sprinkles.

MACARON

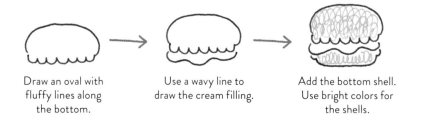

Draw an oval with fluffy lines along the bottom.

Use a wavy line to draw the cream filling.

Add the bottom shell. Use bright colors for the shells.

CAKE

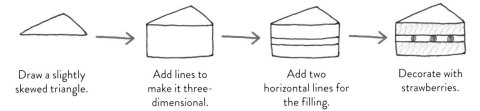

Draw a slightly
skewed triangle.

Add lines to
make it three-
dimensional.

Add two
horizontal lines for
the filling.

Decorate with
strawberries.

TART

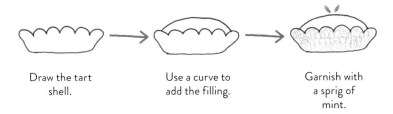

Draw the tart
shell.

Use a curve to
add the filling.

Garnish with
a sprig of
mint.

ROLLED CAKE

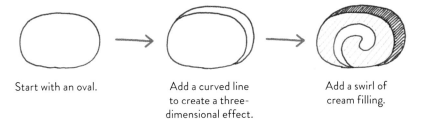

Start with an oval.

Add a curved line
to create a three-
dimensional effect.

Add a swirl of
cream filling.

MUFFIN

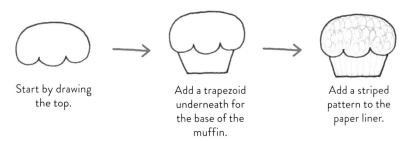

Start by drawing
the top.

Add a trapezoid
underneath for
the base of the
muffin.

Add a striped
pattern to the
paper liner.

MONT BLANC

Draw loose spirals for
the whipped cream.

Add a trapezoid
underneath.

Top with a
chestnut.

DONUT

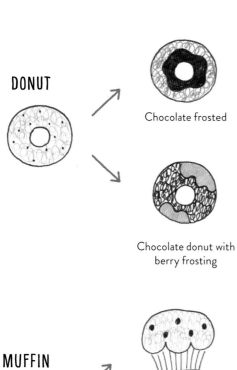

Chocolate frosted

Chocolate donut with berry frosting

PANCAKES

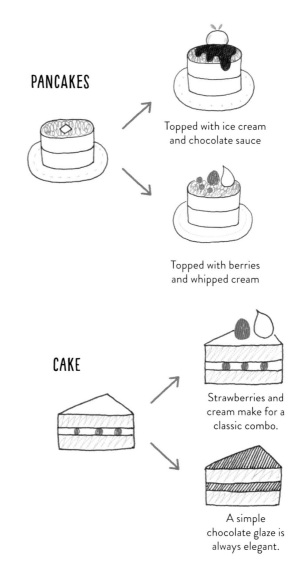

Topped with ice cream and chocolate sauce

Topped with berries and whipped cream

MUFFIN

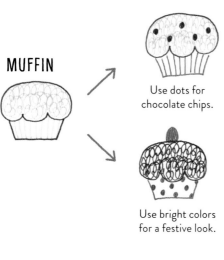

Use dots for chocolate chips.

Use bright colors for a festive look.

CAKE

Strawberries and cream make for a classic combo.

A simple chocolate glaze is always elegant.

MACARON

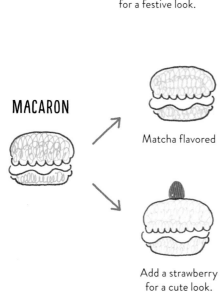

Matcha flavored

Add a strawberry for a cute look.

TART

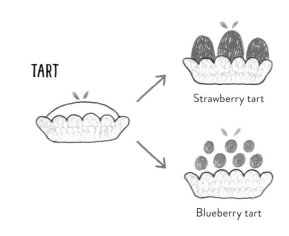

Strawberry tart

Blueberry tart

TEA

Fill about half the cup with liquid. Add a slice of lemon.

COFFEE

Draw a deeper cup. You can even create latte art!

TO-GO CUP

Draw your favorite coffee shop's logo on the cup.

ICED TEA

Draw ice cubes for a refreshing look.

MILK

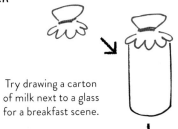

Try drawing a carton of milk next to a glass for a breakfast scene.

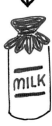

SODA

Use small circles for the bubbles. Add a scoop of ice cream on top for a float.

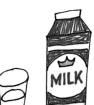

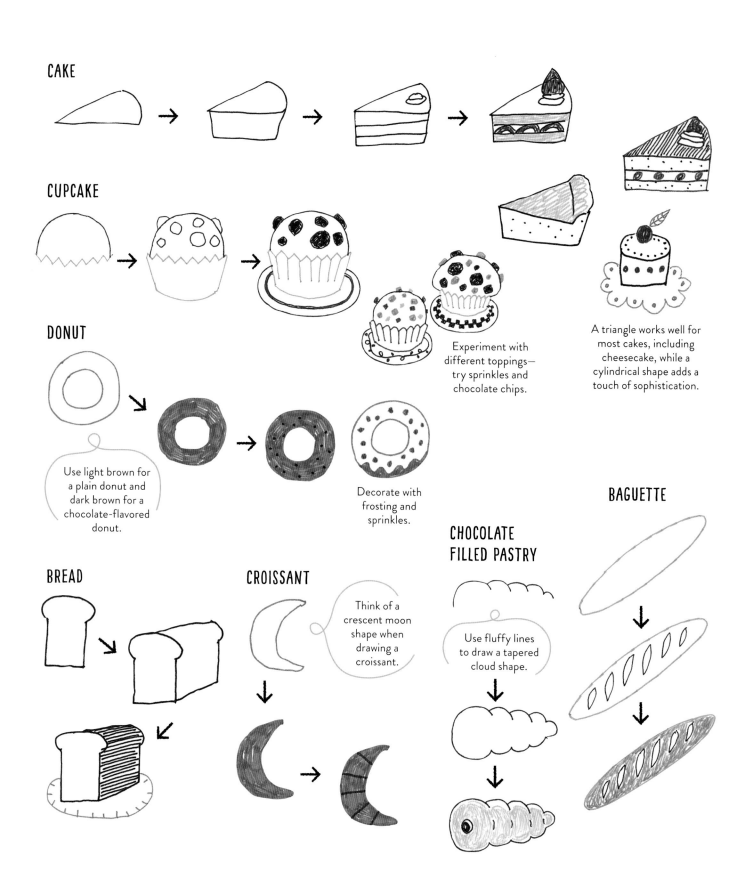

CAKE

CUPCAKE

DONUT

Use light brown for a plain donut and dark brown for a chocolate-flavored donut.

Decorate with frosting and sprinkles.

Experiment with different toppings—try sprinkles and chocolate chips.

A triangle works well for most cakes, including cheesecake, while a cylindrical shape adds a touch of sophistication.

BAGUETTE

CHOCOLATE FILLED PASTRY

Use fluffy lines to draw a tapered cloud shape.

BREAD

CROISSANT

Think of a crescent moon shape when drawing a croissant.

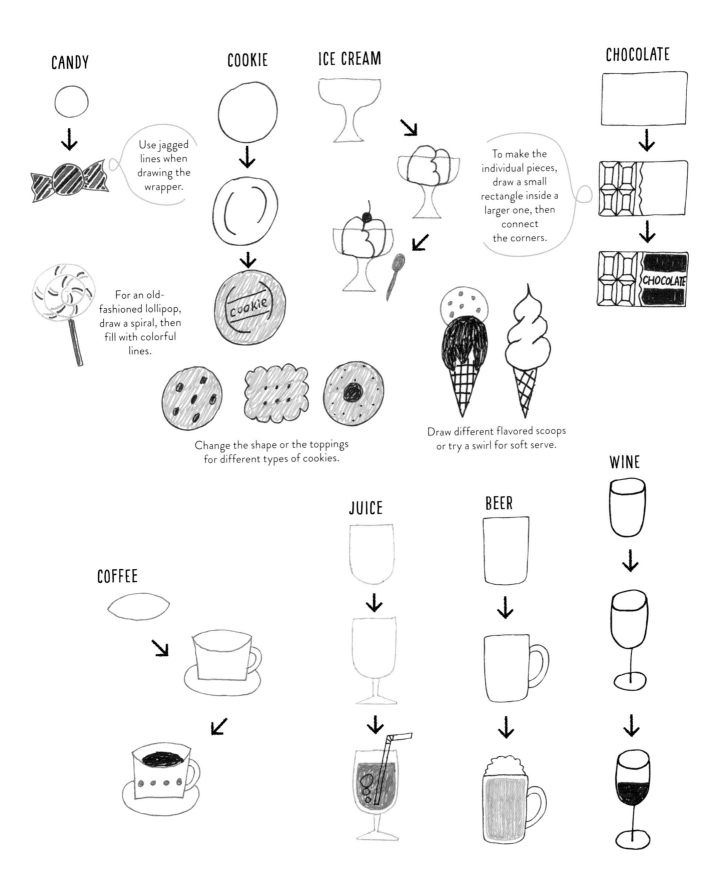

CANDY

Use jagged lines when drawing the wrapper.

For an old-fashioned lollipop, draw a spiral, then fill with colorful lines.

COOKIE

cookie

Change the shape or the toppings for different types of cookies.

ICE CREAM

To make the individual pieces, draw a small rectangle inside a larger one, then connect the corners.

Draw different flavored scoops or try a swirl for soft serve.

CHOCOLATE

CHOCOLATE

COFFEE

JUICE

BEER

WINE

INTERNATIONAL CUISINE

These illustrations were inspired by popular dishes from all over the world. They're perfect for doodling on menus and meal plans.

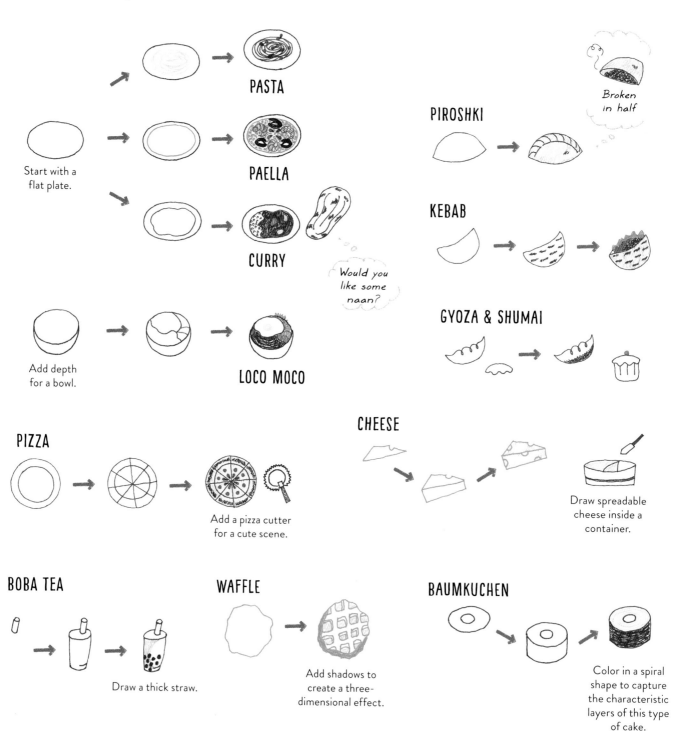

Start with a flat plate.

PASTA

PAELLA

CURRY

Would you like some naan?

Add depth for a bowl.

LOCO MOCO

PIROSHKI

Broken in half

KEBAB

GYOZA & SHUMAI

PIZZA

Add a pizza cutter for a cute scene.

CHEESE

Draw spreadable cheese inside a container.

BOBA TEA

Draw a thick straw.

WAFFLE

Add shadows to create a three-dimensional effect.

BAUMKUCHEN

Color in a spiral shape to capture the characteristic layers of this type of cake.

SPECIAL LESSON: THREE COLOR BALLPOINT PEN TECHNIQUES

CUTE THREE COLOR MOTIFS

You don't need a zillion different color pens to draw cute motifs!
Try using just three shades to create fun doodles. This
type of pen holds three ink refills, so you can make
your own special ballpoint pen.

Apple — Red × Yellow × Light Green

Color in with a mesh pattern, then overlay with yellow and
more red to fill the gaps. Use light green for the stem and leaf.

Flower — Green × Purple × Pink

Try different color combinations to create simple flower motifs.

Bow — Red × Blue × Light Green

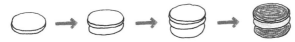

Even when using the same three colors, you can change the
overall impression just by altering the color placement.

Flag — Green × Yellow × Red

Primary colors create a fun impression.

Macaron — Black × Pink × Yellow

Use black for the outline, and the bright colors
for the shell and cream filling.

Try some cute color combinations.

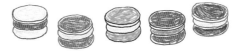

THREE COLOR COMBINATIONS TO TRY

Classic? Not-so-classic? Have fun experimenting to find the perfect color combinations for your doodles.

Light Green × Light Blue × Red

Black × Yellow × Light Green

Yellow × Purple × Green

Pink × Purple × Black

Blue × Green × Pink

Brown × Pink × Light Green

FLOWERS & PLANTS

You can grow a garden full of beautiful flowers—no green thumb necessary, all you need is a ballpoint pen!

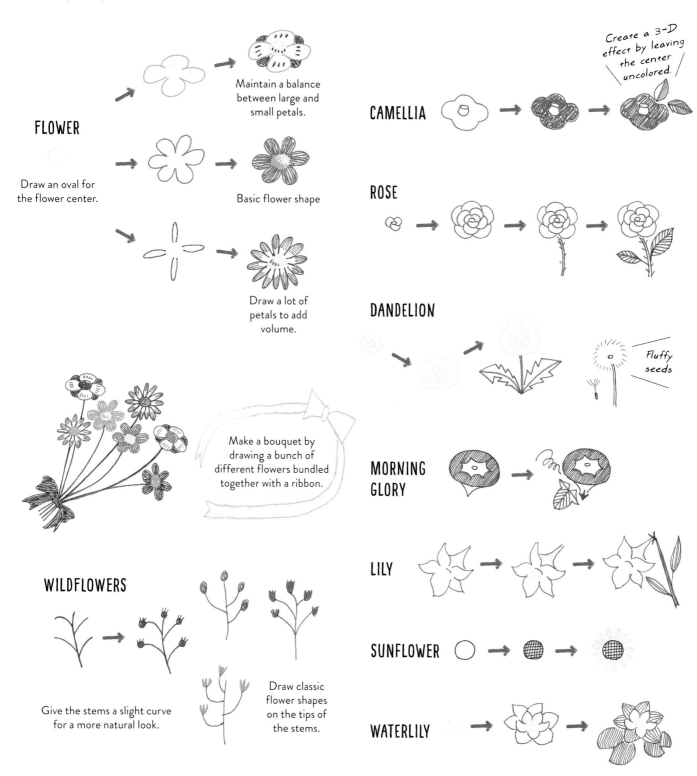

FLOWER

Draw an oval for the flower center.

Maintain a balance between large and small petals.

Basic flower shape

Draw a lot of petals to add volume.

Make a bouquet by drawing a bunch of different flowers bundled together with a ribbon.

WILDFLOWERS

Give the stems a slight curve for a more natural look.

Draw classic flower shapes on the tips of the stems.

CAMELLIA

Create a 3-D effect by leaving the center uncolored.

ROSE

DANDELION

Fluffy seeds

MORNING GLORY

LILY

SUNFLOWER

WATERLILY

CHERRY BLOSSOM

When drawing the petals, imagine a small chunk has been clipped out.

Draw a star, then add dots at the center of the flower.

DANDELION

Draw a rounded cross.

Use the same color to draw a burst made of fluffy lines.

Add an even larger burst.

To depict seeds floating through the air, draw small black ovals with lines extending from one end.

MORNING GLORY

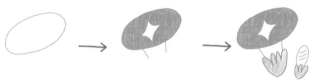

Draw a horizontal oval on a slight angle.

Add color, leaving a large diamond uncolored at the center.

Use green to draw the calyx at the base of the flower.

SUNFLOWER

Draw an orange circle.

Fill the circle with a diagonal grid pattern.

Add large, bright yellow petals.

COSMOS

Draw jagged petals.

Add a yellow circle at the center.

Add color.

CAMELLIA

Draw a soft, uneven circle.

Draw small dots for the stamens.

Use semicircles for the leaves.

Draw a circle, then divide using diagonal lines.

DANDELION

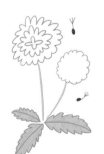

MORNING GLORY

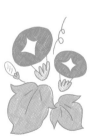

SUNFLOWER

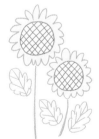

COSMOS

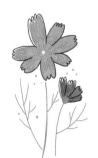

ROSE

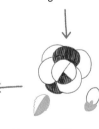
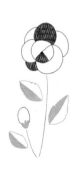

Use curved lines to draw large, overlapping petals for a rose in bloom.

MORNING GLORY

SUNFLOWER

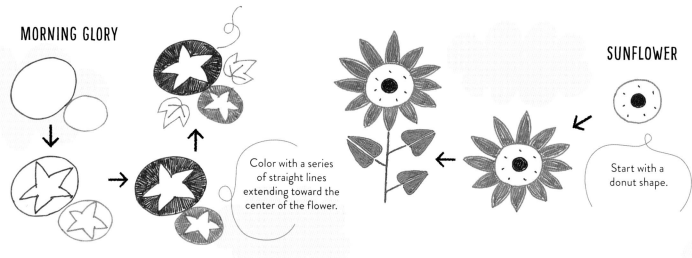

Color with a series of straight lines extending toward the center of the flower.

Start with a donut shape.

PLUM BLOSSOM

CAMELLIA

LEAVES

ACORN

PINE CONE

Try experimenting with leaf shape—circles, hearts, and triangles all work well.

MAPLE

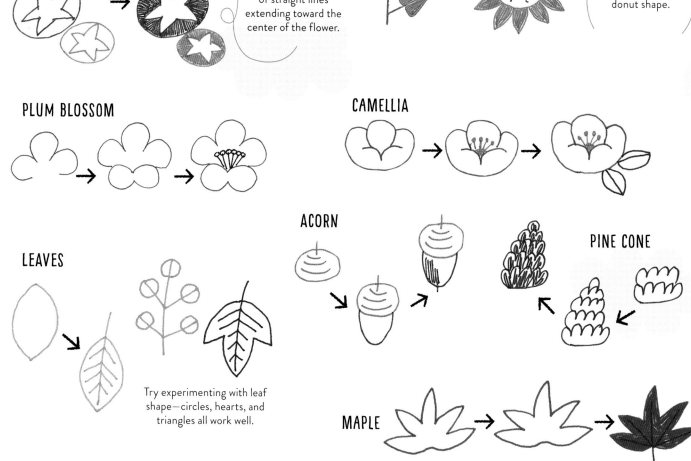

TREE

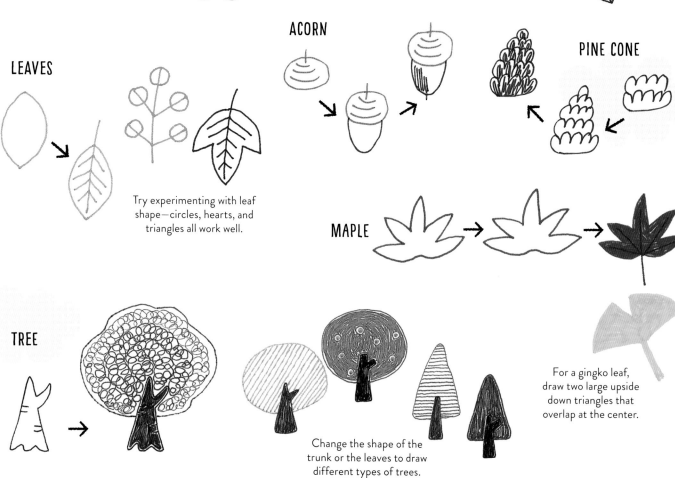

For a gingko leaf, draw two large upside down triangles that overlap at the center.

Change the shape of the trunk or the leaves to draw different types of trees.

ROSE

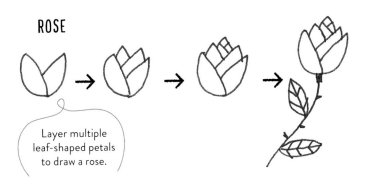

Layer multiple leaf-shaped petals to draw a rose.

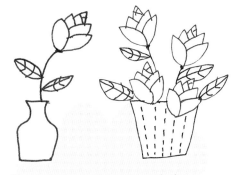

Draw a single rose for an elegant look or an entire bouquet arranged in a vase.

GERBERA

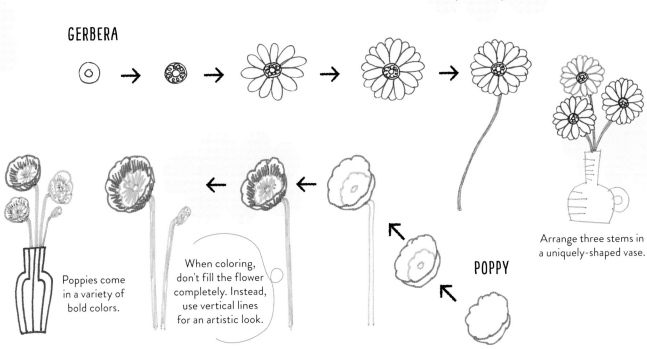

Arrange three stems in a uniquely-shaped vase.

Poppies come in a variety of bold colors.

When coloring, don't fill the flower completely. Instead, use vertical lines for an artistic look.

POPPY

BOUQUET

Even a simple bouquet is beautiful when it features bright colors.

Try drawing a single flower wrapped in cellophane. Use gray triangular outlines to capture the transparency of the cellophane.

IN THE KITCHEN

With their unique shapes and fun design elements, dishes, utensils, and cooking equipment can be fun to draw. Combine these illustrations with the food doodles on pages 46-56 for a lively kitchen scene!

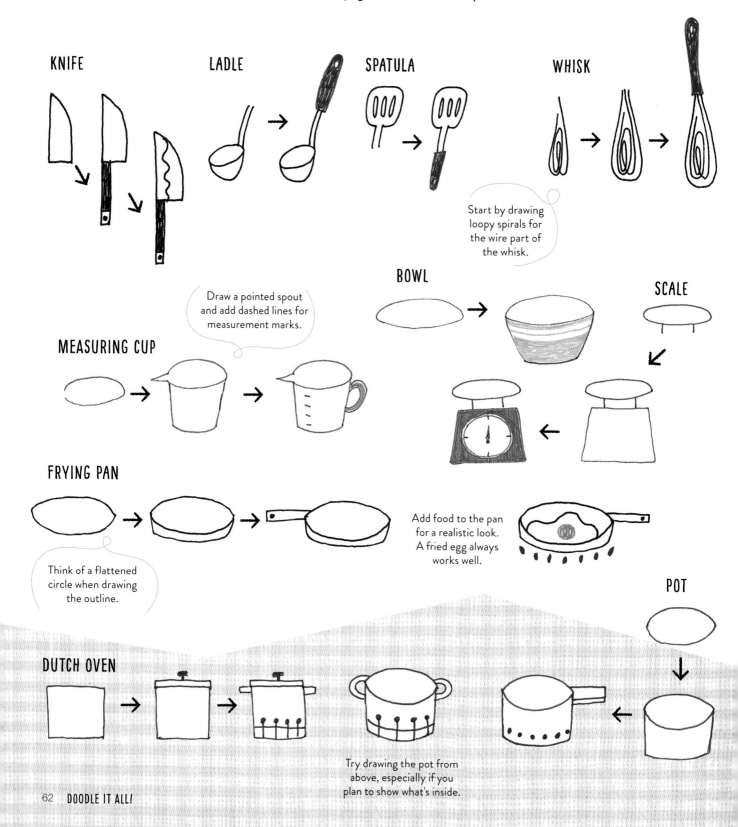

KNIFE

LADLE

SPATULA

WHISK

Start by drawing loopy spirals for the wire part of the whisk.

Draw a pointed spout and add dashed lines for measurement marks.

BOWL

SCALE

MEASURING CUP

FRYING PAN

Add food to the pan for a realistic look. A fried egg always works well.

Think of a flattened circle when drawing the outline.

POT

DUTCH OVEN

Try drawing the pot from above, especially if you plan to show what's inside.

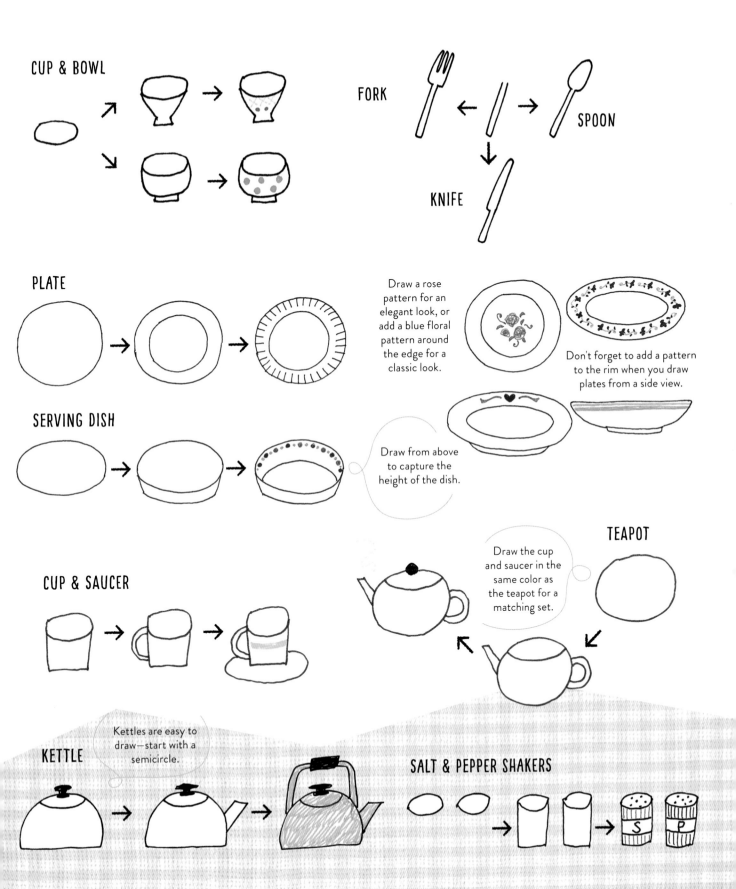

CUP & BOWL

FORK

SPOON

KNIFE

PLATE

Draw a rose pattern for an elegant look, or add a blue floral pattern around the edge for a classic look.

Don't forget to add a pattern to the rim when you draw plates from a side view.

SERVING DISH

Draw from above to capture the height of the dish.

TEAPOT

Draw the cup and saucer in the same color as the teapot for a matching set.

CUP & SAUCER

KETTLE

Kettles are easy to draw—start with a semicircle.

SALT & PEPPER SHAKERS

AROUND THE HOUSE

These illustrations focus on items you'd see around the house, such as tables and chairs. Add special details to change the style of the furniture and play around with the layout to design your perfect room.

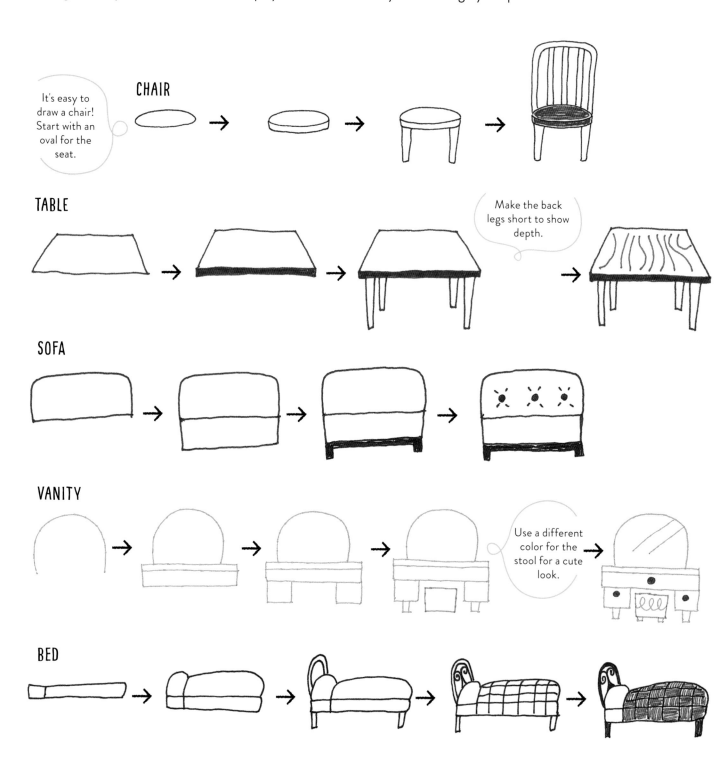

CHAIR

It's easy to draw a chair! Start with an oval for the seat.

TABLE

Make the back legs short to show depth.

SOFA

VANITY

Use a different color for the stool for a cute look.

BED

BASKET

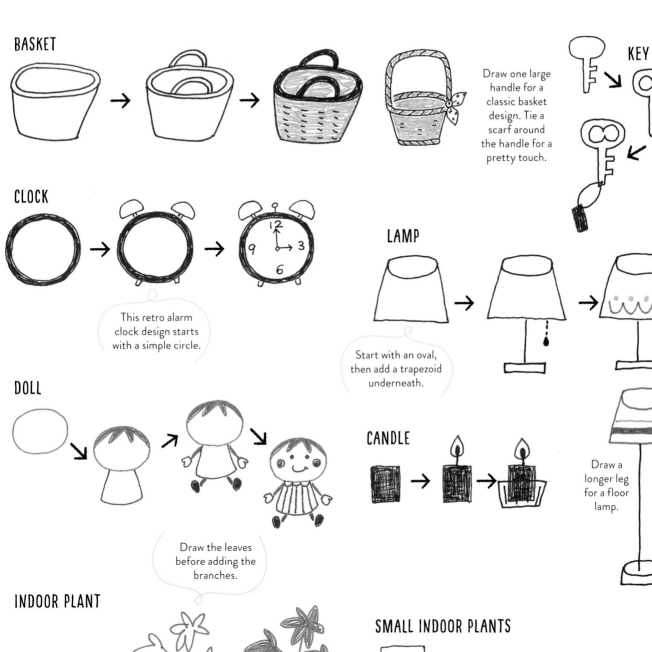

Draw one large handle for a classic basket design. Tie a scarf around the handle for a pretty touch.

KEY

CLOCK

This retro alarm clock design starts with a simple circle.

LAMP

Start with an oval, then add a trapezoid underneath.

DOLL

CANDLE

Draw a longer leg for a floor lamp.

Draw the leaves before adding the branches.

INDOOR PLANT

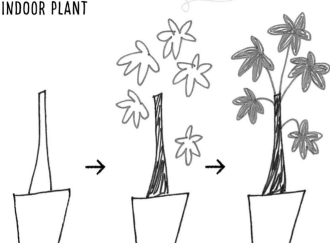

SMALL INDOOR PLANTS

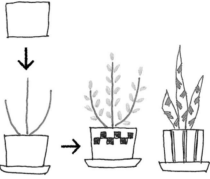

Use different shapes for the leaves and add unique patterns to the pots.

TABLE

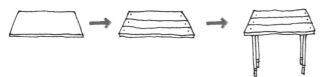 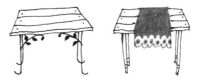

Simply draw a rectangle, then add legs.

Add unique design elements, such as iron legs or a tablecloth.

SOFA

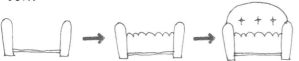

Use a rounded shape for the back.

Add a pattern to change up the style.

VARIATIONS

SEWING SET

BUTTONS Start with the basic shape, then add details

Paper bobbin

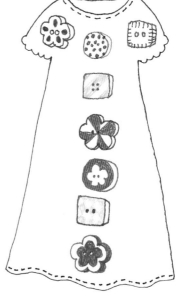

THREAD

Cute colorful threads

NEEDLE **PIN**

Pin cushion

The uncolored area serves as a highlight.

Try arranging buttons randomly on a dress. You're the fashion designer!

SPECIAL LESSON: COLLAGE & PATTERN TECHNIQUES

MASKING TAPE

Try incorporating masking tape, also known as washi tape, into your doodles to make interesting collage-style illustrations.

Washi tape is available in all sorts of interesting colors and patterns. It's popular for its unique semi-transparent look and is easily removed.

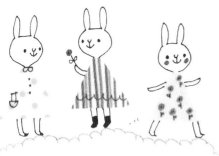

Cut a triangular piece of tape to make a dress. Use ballpoint pen to add some pattern to the tape.

Align like colors diagonally for a checkerboard window. Then draw a person peeking out the window.

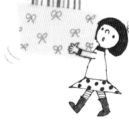

Stack small rectangles of tape to create gift boxes. The key is to offset the pieces of tape slightly.

Draw characters snoozing beneath a roughly torn piece of tape. Animal characters look particularly cute!

FABRIC

Want to make cute embroidery-style items, but don't know how to sew? Use a ballpoint pen instead!

Use a ballpoint pen specifically designed to work on fabric. These pens will have fine tips, allowing you to create delicate, detailed illustrations.

Practice drawing your design on paper first. Use short lines to create the look of running stitch and blanket stitch.

STATIONERY

These items should be familiar since we use them every day at school and at work. They all feature simple shapes, so they should be easy to draw.

PEN

Draw a stick with a rounded tip.

Add a diamond shape at the base for the nib.

Add a small black circle and a vertical line to the nib.

Decorate with polka dots for a cheerful look.

Draw a triangular black tip to create a pencil.

For added cuteness, draw an animal eraser on the end.

NOTEBOOK

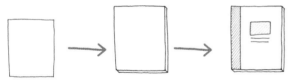

Draw a vertical rectangle.

Add some outlines to show the thickness.

Add the spine and a label to the front.

Add regularly spaced rings to the spine for a spiral notebook.

Use horizontal lines to represent text when drawing an open notebook.

Or try adding cute illustrations to the cover.

SCISSORS

Draw two ovals with holes in the middle.

Add two crossed semicircles.

Color the handles.

ERASER

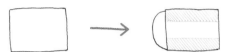

Draw a
horizontal
rectangle.

Add a
semicircle to
one end for an
eraser inside a
cardboard case.

TAPE

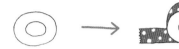

Make a circle
with a hole in
the middle.

Add color and
pattern to
create washi
tape.

PENCIL SHARPENER

Draw a vertical
rectangle with
rounded corners.

Add an L-shaped
handle.

Use a vertical and
a horizontal line to
separate into sections.
Draw a black circle for
inserting the pencil.

COMPASS

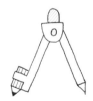

Concentrate on
the main elements
when drawing this
unique tool.

PROTRACTOR

Start with a
semicircle, then
use diagonal lines
to divide into pie-
shaped segments.

SET SQUARE

Make short, evenly
spaced lines along
the straight edge to
create a scale.

ABACUS

Arrange columns of
four beads beneath a
single bead.

NOTEBOOK

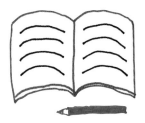

Draw a pencil next to an open notebook.

PENCIL PEN CRAYON

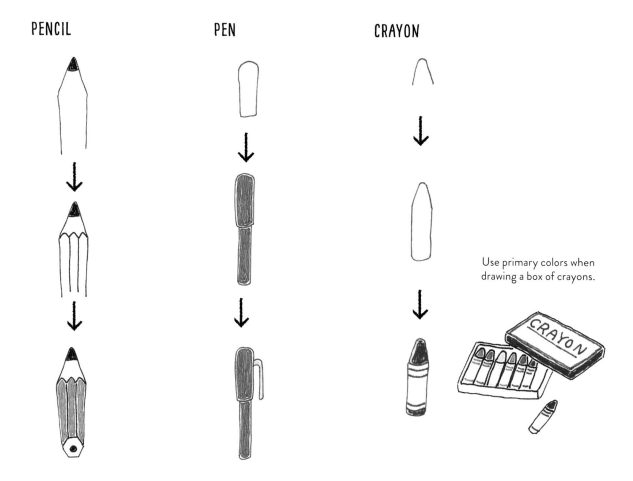

Use primary colors when drawing a box of crayons.

Draw the cap alongside the pen for an active writing scene.

SCISSORS

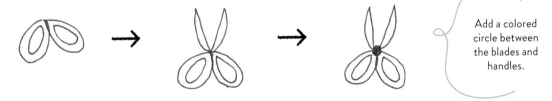

Add a colored circle between the blades and handles.

ENVELOPE

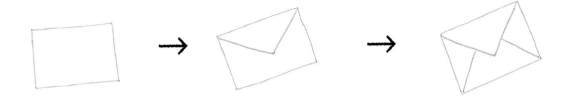

ERASER

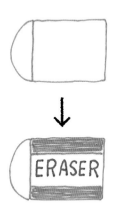

Try drawing different envelope shapes and designs based on the contents.

VARIATIONS

LET'S DRAW ENVELOPES

Change up the style of the envelope based on the message. Use a red and blue border for airmail, draw a manila envelope, or add a heart for a love letter.

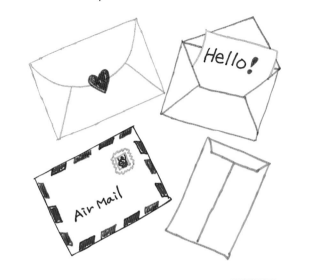

Hello!

Air Mail

CLOTHING & ACCESSORIES

Have you ever wondered what it would be like to be a fashion designer? Here's your chance! Try your hand at designing your own clothing and accessories—experiment with different silhouettes, colors, and patterns.

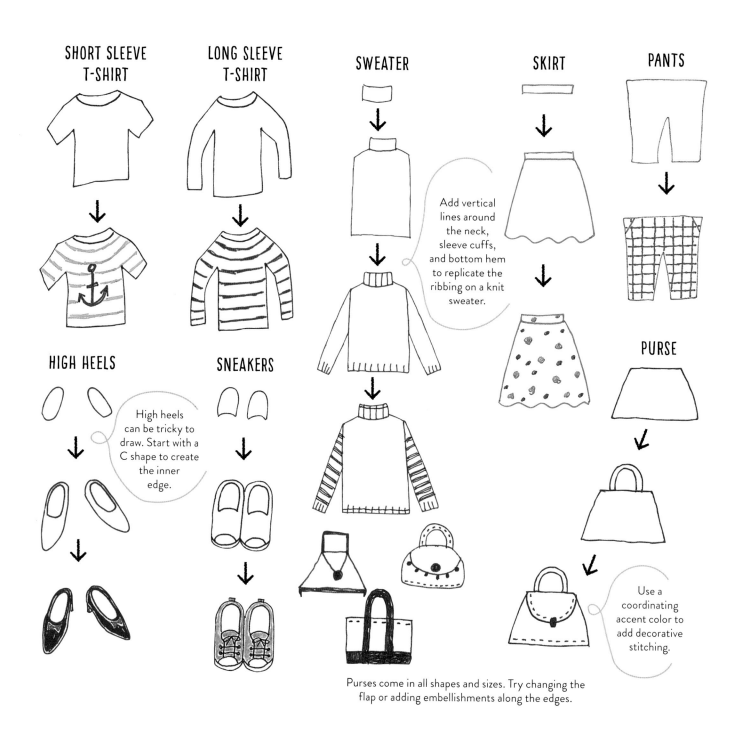

SHORT SLEEVE T-SHIRT

LONG SLEEVE T-SHIRT

SWEATER

SKIRT

PANTS

Add vertical lines around the neck, sleeve cuffs, and bottom hem to replicate the ribbing on a knit sweater.

HIGH HEELS

High heels can be tricky to draw. Start with a C shape to create the inner edge.

SNEAKERS

PURSE

Use a coordinating accent color to add decorative stitching.

Purses come in all shapes and sizes. Try changing the flap or adding embellishments along the edges.

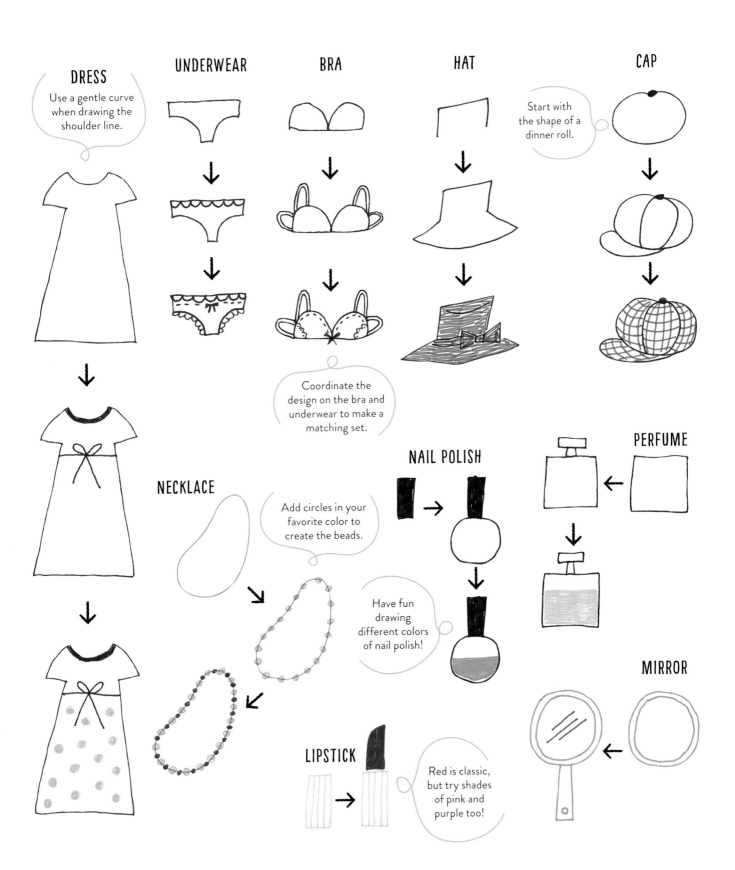

DRESS

Use a gentle curve when drawing the shoulder line.

UNDERWEAR

BRA

Coordinate the design on the bra and underwear to make a matching set.

HAT

CAP

Start with the shape of a dinner roll.

NECKLACE

Add circles in your favorite color to create the beads.

NAIL POLISH

Have fun drawing different colors of nail polish!

PERFUME

MIRROR

LIPSTICK

Red is classic, but try shades of pink and purple too!

PERFUME

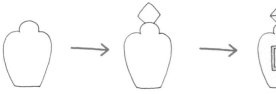

Draw a rounded bottle with an extended neck.

Add a diamond-shaped cap.

Add a rectangular label to the middle of the bottle.

Add a sprinkling of polka dots for a feminine look.

Or use pastel colors and add a pretty bow.

A purple color scheme creates a more mature look.

COMPACT

Draw a vertical and a horizontal oval that meet at the end.

Outline the ovals to add thickness.

Draw a puff in the bottom oval and a mirror in the top oval. Color the mirror with diagonal lines.

You can use different colors and shapes to create stylish compacts.

PUFF

Use fluffy lines to draw a cloud shape.

Add a bow for the handle.

MAKEUP BRUSH

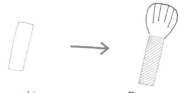

Draw a thin rectangle.

Draw a trapezoid with rounded corners.

LIPSTICK

Draw a vertical rectangle.

Add a small square on top.

Draw a diagonal oval, then add vertical lines to create an angled cylinder.

Add a lace pattern to the tube for a touch of sophistication.

SOAP

Draw bubbles on top of a squat oval.

Draw a flat soap dish underneath.

HAND MIRROR

Draw a vertical oval.

Add another oval around the first one, with a handle extending from the bottom.

Pretty details, such as a scalloped outline and a bow, give this hand mirror a pretty look.

HAIR BRUSH

A rounded tip makes for a pretty accent.

Add a pattern to the back.

BODY BRUSH

Start with a cylinder for the brush.

Draw a long handle.

COMB

Start with the outline of the comb.

Add lines for the teeth.

NAIL POLISH

Draw a vertical rectangle.

Draw a wide oval for the bottle.

RING

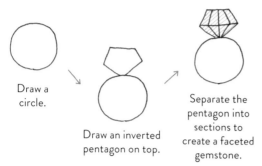

Draw a circle.

Draw an inverted pentagon on top.

Separate the pentagon into sections to create a faceted gemstone.

EARRING

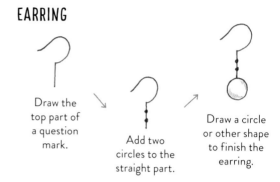

Draw the top part of a question mark.

Add two circles to the straight part.

Draw a circle or other shape to finish the earring.

NECKLACE ## BOOTS

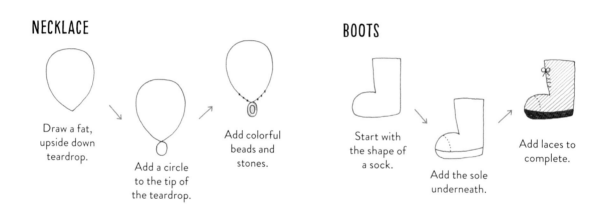

Draw a fat, upside down teardrop.

Add a circle to the tip of the teardrop.

Add colorful beads and stones.

Start with the shape of a sock.

Add the sole underneath.

Add laces to complete.

PUMPS

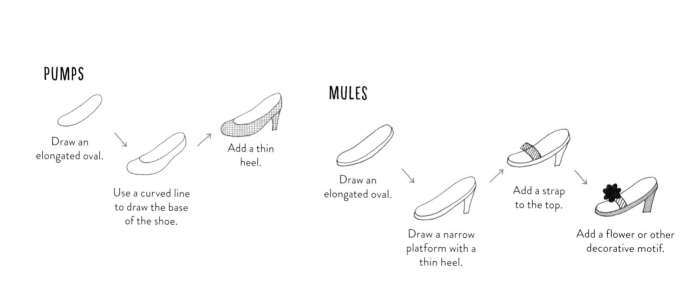

Draw an elongated oval.

Use a curved line to draw the base of the shoe.

Add a thin heel.

MULES

Draw an elongated oval.

Draw a narrow platform with a thin heel.

Add a strap to the top.

Add a flower or other decorative motif.

BAG

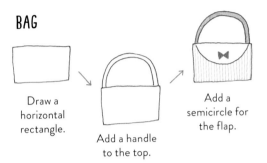

Draw a
horizontal
rectangle.

Add a handle
to the top.

Add a
semicircle for
the flap.

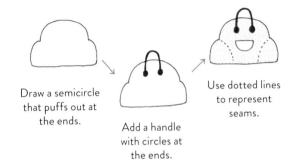

Draw a semicircle
that puffs out at
the ends.

Add a handle
with circles at
the ends.

Use dotted lines
to represent
seams.

PURSE

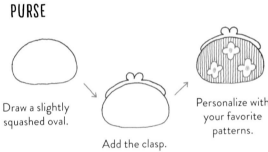

Draw a slightly
squashed oval.

Add the clasp.

Personalize with
your favorite
patterns.

STRAW HAT

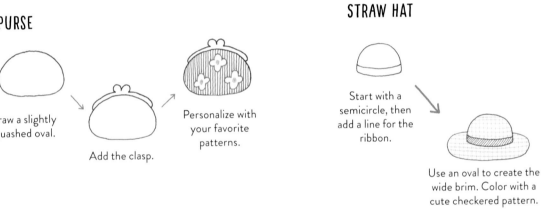

Start with a
semicircle, then
add a line for the
ribbon.

Use an oval to create the
wide brim. Color with a
cute checkered pattern.

SUNGLASSES

Draw two semicircles
connected with a
horizontal line.

Add the
temples.

EARMUFFS

Draw two
fluffy circles.

Connect them
with a curved line.

MITTENS

Draw a
fluffy oval.

Draw two
mountain
shapes on top.

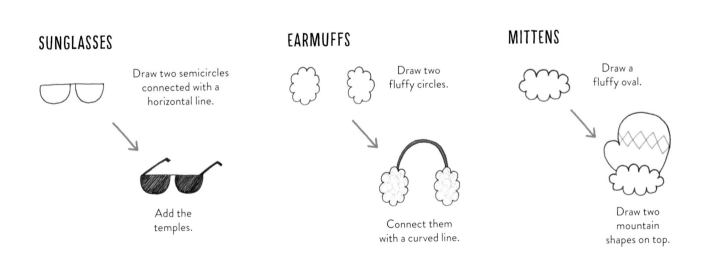

LET'S DRAW T-SHIRTS

STRIPES • Try different lines to create cute patterns!

Add scallops to the sleeves too!

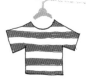 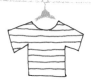 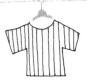

| Thick Stripes | Thin Stripes | Vertical | Plaid | Wavy Lines | Zebra |

POLKA DOTS • Change the size and color of the patterns.

Use brown and yellow for a realistic color scheme.

| Small Dots | Big Dots | Circles | Grouped Dots | Raindrops | Leopard |

SQUARES • Try combining different colors to make bold patterns.

Combine diamonds and diagonal dashed lines.

| Overlapping Squares | Checkered | Patchwork | Diamonds | Argyle | Nordic |

VARIOUS MOTIFS • Hearts, stars, flowers...the possibilities are endless!

Try a stylish three color pattern.

| Hearts | Overlapping Hearts | Stars | Outlined Stars | Small Flowers | Camo | Paisley |

SPECIAL LESSON: ERASABLE BALLPOINT PEN TECHNIQUES

DRAW OVERLAPPING ILLUSTRATIONS

When two illustrations overlap, just remove one line to add depth. The illustration below uses a rabbit and house motif as an example.

With this special type of pen, the ink becomes transparent when exposed to the friction and heat created by rubbing the eraser. These pens are convenient because they allow you to redraw an image as many times as you like!

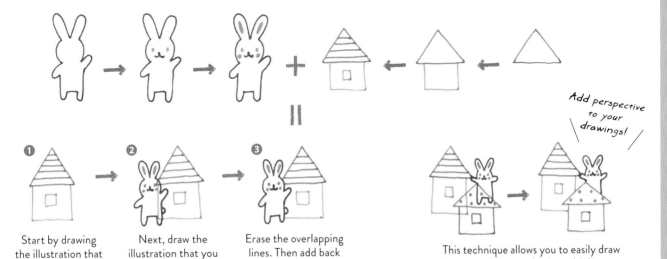

Add perspective to your drawings!

Start by drawing the illustration that you want to appear underneath.

Next, draw the illustration that you want to appear in front of ❶.

Erase the overlapping lines. Then add back any lines of ❷ that were erased with ❶.

This technique allows you to easily draw illustrations that overlap in multiple spots.

ADD HIGHLIGHTS

You can add highlights to your illustrations just by erasing the ink from certain areas.

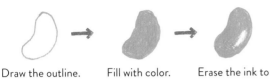

Draw the outline. Fill with color. Erase the ink to highlight an area.

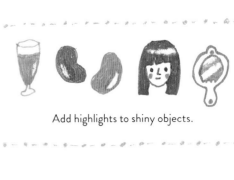

Add highlights to shiny objects.

ADD SHADING

Lightly erase to create an artistically shaded illustration.

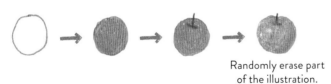

Randomly erase part of the illustration.

This technique works well for round objects.

HOBBIES

This collection of doodles is all about fun! You'll find examples of your favorite sports and activities, like art, music, and crafting.

OUTDOOR HOBBIES

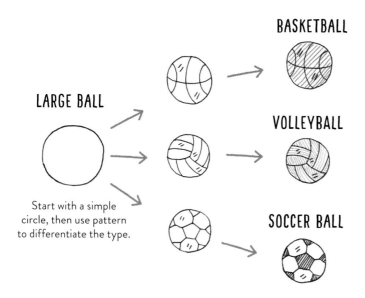

LARGE BALL

Start with a simple circle, then use pattern to differentiate the type.

BASKETBALL

VOLLEYBALL

SOCCER BALL

BASEBALL BAT

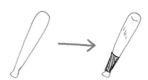

Draw a tapered cylinder and color the handle.

BASEBALL GLOVE

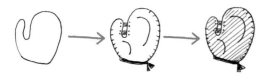

Just like a mitten, a baseball glove has a separate spot for the thumb. Use lines to show the seams.

GOLF CLUB

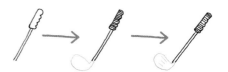

The grip should be wavy on one side and the head of the club should be square with rounded corners.

SMALL BALL

Start with a small circle. Think about the color and texture to create a specific type.

BASEBALL

TENNIS BALL

GOLF BALL

TENNIS RACQUET

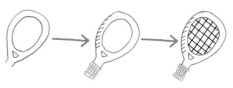

Start with an oval and draw a small triangle underneath. Make the grip short. Draw vertical and horizontal lines for the strings.

TENT

Start with a triangle, then add a square to make it three-dimensional.

Add a pattern to the roof.

Don't forget the tent stakes!

CAMPFIRE

Use red to make a jagged shape.

Draw brown rectangles for the firewood.

Use red lines to color the fire.

SURFBOARD

Draw a rounded triangle.

Decorate with wavy lines and colored edges.

Add a striped pattern.

BICYCLE

Draw two double circles.

Draw a line extending from the center of the front wheel to create the handlebars.

Uses triangles to draw the frame.

Add color for the handle and seat.

 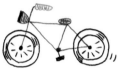

Add a pedal and spokes to complete.

INDOOR HOBBIES

VIOLIN

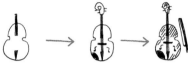

Draw a figure eight-shaped body.

Add the strings. Don't forget to add a bow!

PIANO

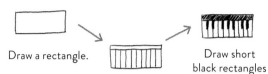

Draw a rectangle.

Draw a horizontal line, then add vertical lines underneath.

Draw short black rectangles between the vertical lines.

Draw a gently curved body behind the keyboard.

GUITAR

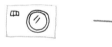

Draw a gourd shape with a long rectangle for the neck.

Draw a circle in the middle and add the strings.

MUSIC BOOK

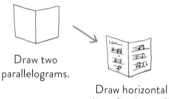

Draw two parallelograms.

Draw horizontal lines for the staff and add the notes.

MUSIC STAND

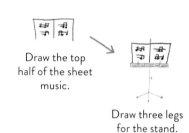

Draw the top half of the sheet music.

Draw three legs for the stand.

CAMERA

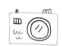 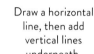

Draw a horizontal rectangle, then add circles for the lens.

Add a square on top for the shutter button.

Digital Camera

Add color.

SLR Camera

Make the lens larger than the body.

Add a trapezoid and a button on top.

Color the SLR camera in classic black.

Draw three legs to make a tripod.

PALETTE

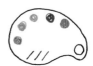

Draw a comma shape and then add a small circle.

Arrange the paint colors along the curve.

Use lots of colorful circles for the paint.

EASEL

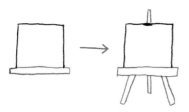

Start with a square then add a thin rectangle underneath. Add three legs.

Use diagonal lines to color the easel.

Add a pretty picture to the canvas.

PAINTBRUSH

Draw a thin stick.

Draw a teardrop shape for the brush.

Add color to the tip of the brush.

PAINT

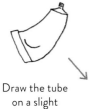

Draw the tube on a slight curve.

Draw your favorite paint color squirting out the top of the tube.

Use the same color for the label.

READING

Draw a V at the top of a thin rectangle.

Draw an open book.

Use a different color for the cover of the book.

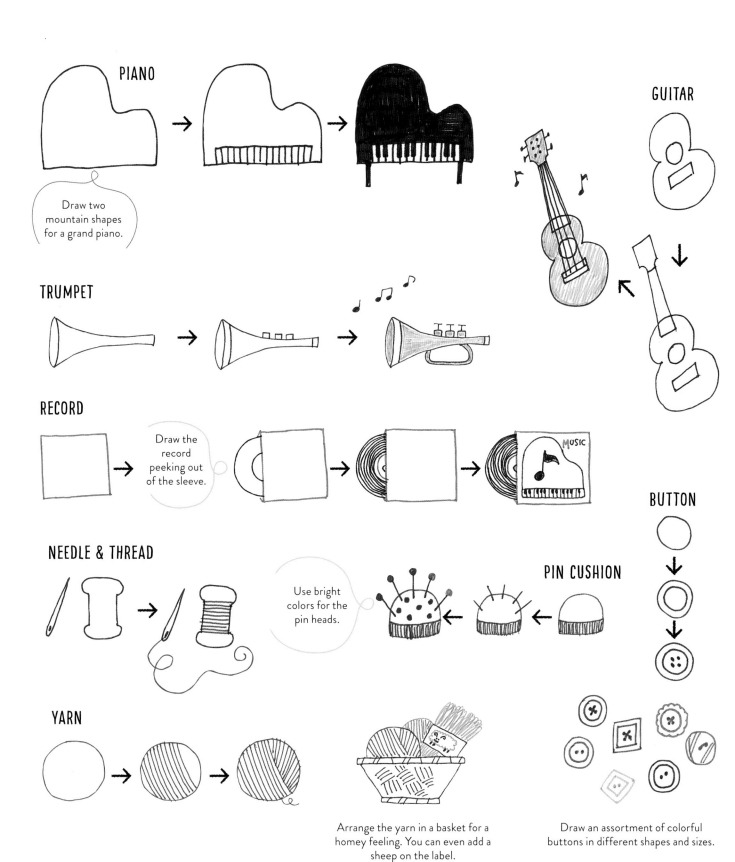

PIANO

Draw two mountain shapes for a grand piano.

GUITAR

TRUMPET

RECORD

Draw the record peeking out of the sleeve.

MUSIC

BUTTON

NEEDLE & THREAD

Use bright colors for the pin heads.

PIN CUSHION

YARN

Arrange the yarn in a basket for a homey feeling. You can even add a sheep on the label.

Draw an assortment of colorful buttons in different shapes and sizes.

TRAVEL

SUITCASE

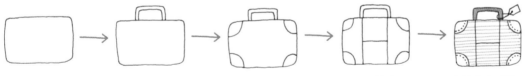

Draw a horizontal rectangle with rounded corners.

Add a handle.

Draw curved lines on the four corners.

Draw an H shape in the middle.

Add dashed lines to the corners to create seams. Add a luggage tag for a special touch.

Decorate the suitcase with polka dots for a some stylish luggage.

ROLLING SUITCASE

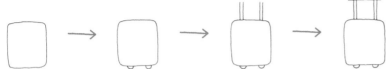
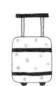

Draw a vertical rectangle with rounded corners.

Add two semicircles for wheels.

Draw two straight sticks on top.

Add a horizontal bar on top of the sticks to complete the handle.

Draw vertical and horizontal lines to make a plaid pattern.

Or decorate with fun designs.

BACKPACK

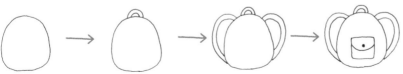
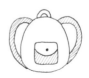

Draw a fat egg shape.

Draw two small curves for the top handle.

Draw two large curves on each side for the straps.

Add a pocket.

Color the pocket and the straps a different color for a bit of contrast.

Try adding a flap for a backpack that opens on the top.

PLANE TICKET

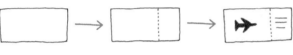

Draw a long rectangle.

Draw a dotted vertical line about ⅔ of the way from the end.

Add a small airplane illustration.

TRAIN TICKET

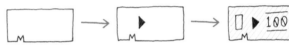

Draw a long rectangle with an M along the bottom edge.

Draw an arrow pointing to the right.

Add some numbers for the time and train fare.

VEHICLES & BUILDINGS

These illustrations feature all sorts of cars, planes, and trains, plus houses, shops, and landmarks.
They are useful for drawing street scenes and maps.

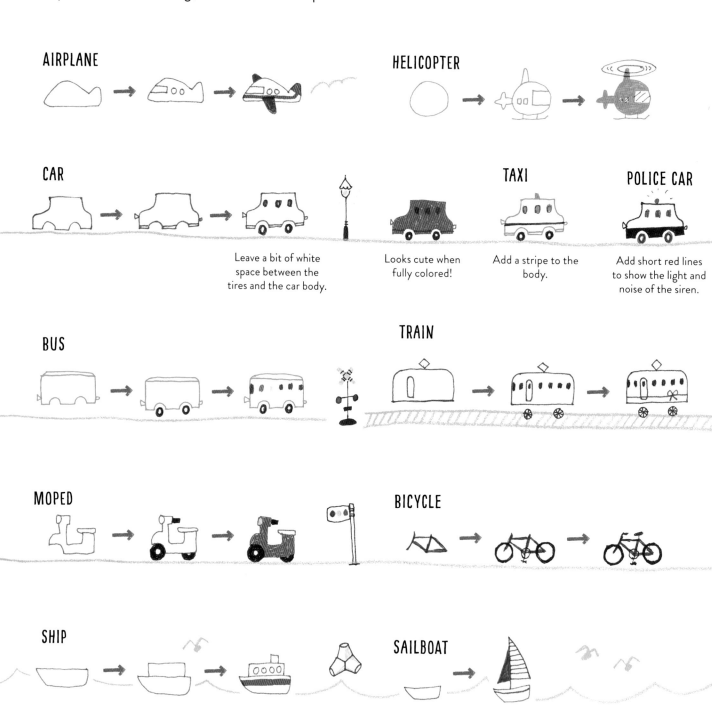

AIRPLANE

HELICOPTER

CAR

Leave a bit of white space between the tires and the car body.

TAXI

Looks cute when fully colored!

Add a stripe to the body.

POLICE CAR

Add short red lines to show the light and noise of the siren.

BUS

TRAIN

MOPED

BICYCLE

SHIP

SAILBOAT

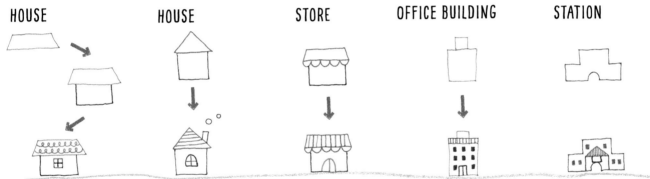

HOUSE

Try a trapezoid roof.

HOUSE

Or use a triangle for a classic design.

STORE

Add an awning to transform a basic building into a shop.

OFFICE BUILDING

Draw a lot of small windows.

STATION

Draw a triangular roof above the entrance to add some interesting architectural elements.

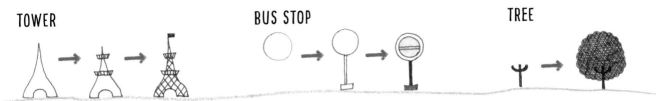

TOWER

Draw a flag on top of the tower.

BUS STOP

Use bright colors to make the sign stand out.

TREE

Try changing the size and height based on the surrounding buildings.

VARIATION

ILLUSTRATED MAP

Try making handmade illustrated maps for your invitations or event itineraries.

TRAIN

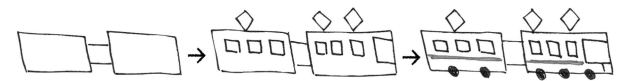

CAR

Draw a puff of exhaust and light beams to show the traveling direction.

Draw a large window for the windshield.

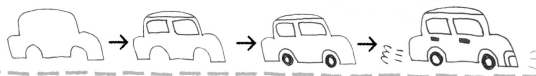

MOTORCYCLE

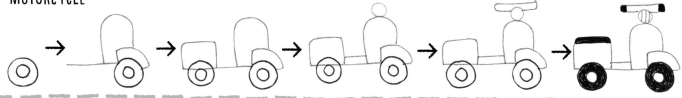

BICYCLE

Connect the two circles with a diamond and a straight line.

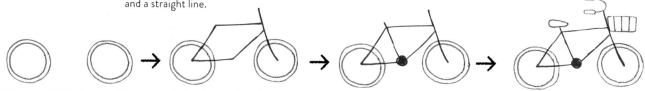

SAILBOAT

Add a square with a cylindrical chimney for a classic tugboat.

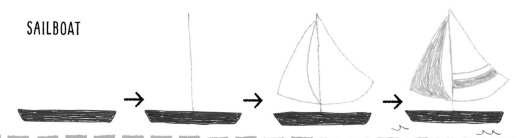

AIRPLANE

The body will taper at the tail.

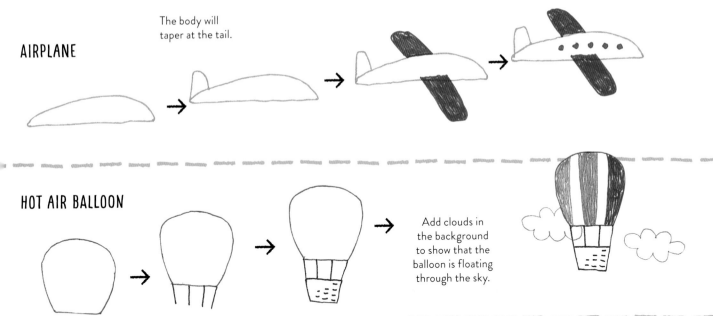

HOT AIR BALLOON

Add clouds in the background to show that the balloon is floating through the sky.

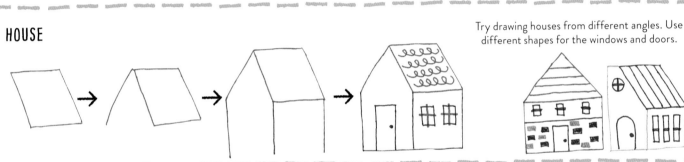

HOUSE

Try drawing houses from different angles. Use different shapes for the windows and doors.

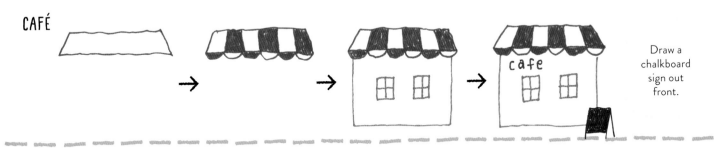

CAFÉ

Draw a chalkboard sign out front.

POST OFFICE

Use the same shape to draw a bank, but change the color scheme.

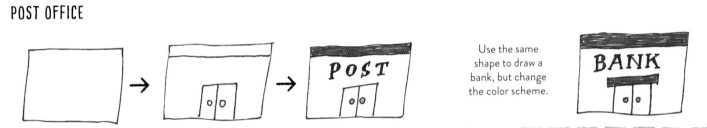

AROUND THE WORLD

Travel around the world with these exotic illustrations! Inspired by the culture and landmarks of other countries, these motifs will give your art a worldly impression.

CULTURAL ICONS

MATRYOSHKA DOLL

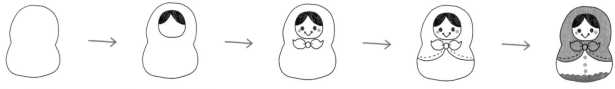

Start with a figure eight shape.

Draw a circle for the face and add bangs.

Add a bow beneath the face. The tips of the bow should point upward.

Embellish the kerchief with dotted lines.

A pink color scheme creates a feminine impression.

Matryoshkas are nesting dolls, so draw a set that ranges in size from small to large.

Use a pink and yellow color scheme for a cheerful look.

Decorate with stripes and flowers.

Or embellish with stars and polka dots.

CALAVERA

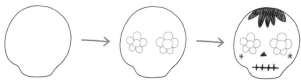

To make the skull shape, draw a circle that tapers in along the jawline.

Draw large flowers for the eyes.

To make the mouth, draw a long horizontal line, then add several short vertical lines.

Use lots of bold colors for a festive look.

Add a sombrero hat.

This calavera features a sunflower-themed design.

DALA HORSE

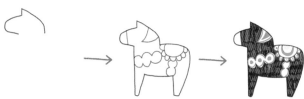

Use a gentle curve for the nose and a sharp line for the ear.

Combine wavy and curved lines to create interesting patterns.

Color the body red, then use your favorite colors as accents.

A simple blue color scheme creates a cool impression.

Scatter varying sizes of polka dots for an artful look.

FAMOUS LANDMARKS

EIFFEL TOWER

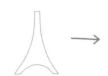 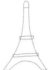 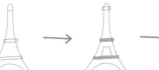

Draw an elongated triangle that curves along each side.

Add two horizontal rectangles.

Add a trapezoid between the two rectangles.

Use crosswise diagonal lines to create the metal pattern and top with a flag.

LEANING TOWER OF PISA

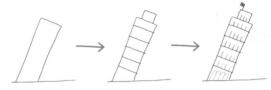

Draw the building on an angle.

Use diagonal lines to divide into floors.

Set the scene with clouds and a flag.

STATUE OF LIBERTY

Draw a rough circle. Add curved lines for the bangs.

Draw five elongated triangles to create the crown.

The right arm should extend from the body.

Draw a tablet in her left hand.

Draw a torch in her right hand.

MOAI STATUE

Draw a sharply pointed nose and a protruding chin.

Use black diagonal lines to add shading to the eye area.

Use gray dots to capture the texture of the stone.

SPHINX

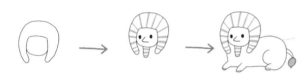

The hair should be longer than the face.

Use orange lines for the hair.

Draw a pyramid off in the distance behind the sphinx.

TOKYO TOWER

Draw an elongated isosceles triangle.

Add two observation decks—one in the middle and one near the top of the tower.

Scatter stars in the background for a nighttime scene.

INTERNATIONAL FLAGS

 Japan
 England
 France
 USA
 Italy

Use wavy lives to draw a flag fluttering in the breeze and create a lively illustration.

 Russia
 Sweden
 Norway
 China
 Canada

Draw crossed flags for a celebratory atmosphere.

ANIMALS FROM AROUND THE WORLD

These animals are from all different parts of the world.

IMPALA
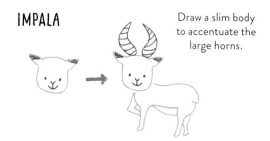

Draw a slim body to accentuate the large horns.

PIRANHA
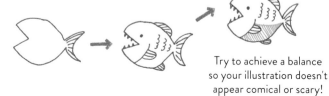

Try to achieve a balance so your illustration doesn't appear comical or scary!

KANGAROO
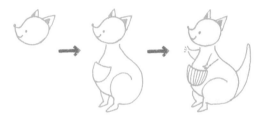

You can even add a baby kangaroo in the pouch!

MANATEE
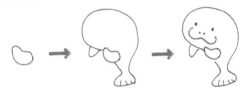

Draw an innocent facial expression for a cute look.

BUFFALO
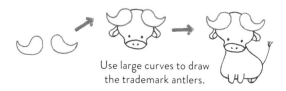

Use large curves to draw the trademark antlers.

RED PANDA
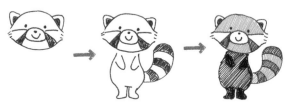

Draw the charming striped patterns on the face and the tail.

PANDA
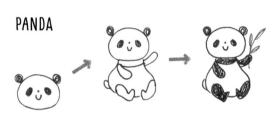

Draw the panda holding a bamboo branch for a playful illustration.

ALLIGATOR
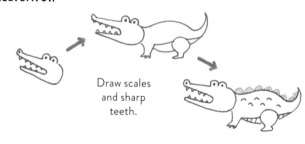

Draw scales and sharp teeth.

WORLD FOLK COSTUMES

This collection of illustrations features stylish folk costumes from various countries. Decorate with simple motifs, such as the floral patterns pictured here.

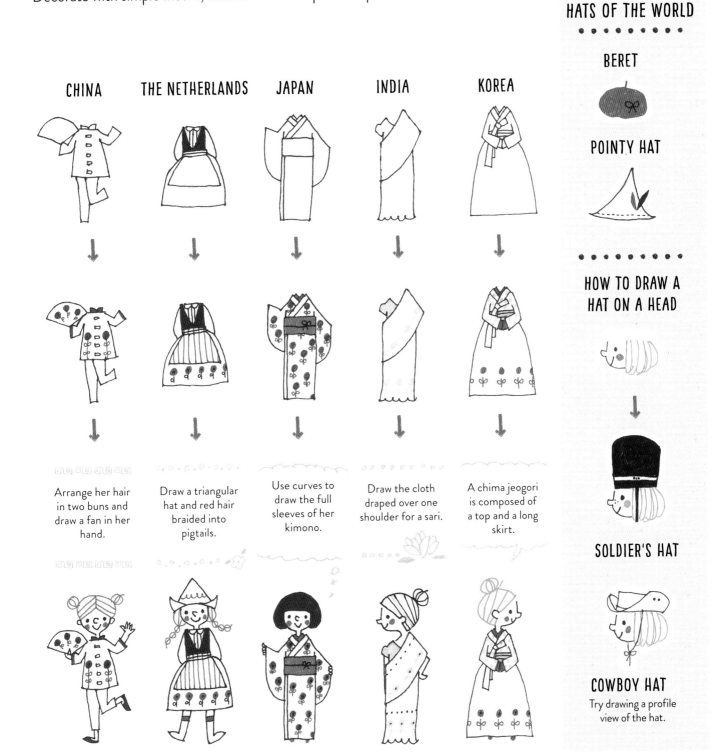

CHINA THE NETHERLANDS JAPAN INDIA KOREA

Arrange her hair in two buns and draw a fan in her hand.

Draw a triangular hat and red hair braided into pigtails.

Use curves to draw the full sleeves of her kimono.

Draw the cloth draped over one shoulder for a sari.

A chima jeogori is composed of a top and a long skirt.

HATS OF THE WORLD

BERET

POINTY HAT

HOW TO DRAW A HAT ON A HEAD

SOLDIER'S HAT

COWBOY HAT

Try drawing a profile view of the hat.

VARIOUS MOTIFS OF THE WORLD

KOKESHI DOLL

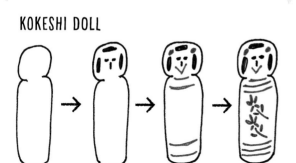

DARUMA

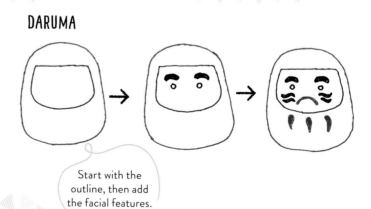

Start with the outline, then add the facial features.

MATRYOSHKA DOLL

Think of a gourd shape when drawing the outline.

Nested matryoshkas are so cute!
Draw a different outfit for each one.

EIFFEL TOWER

DALA HORSE

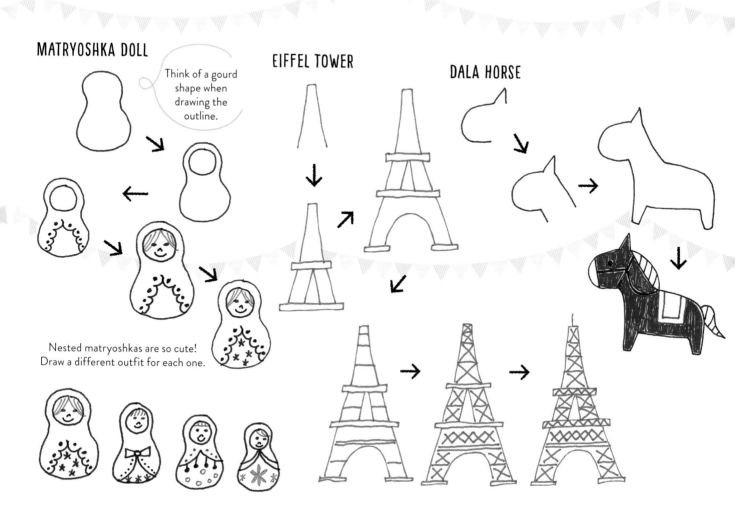

MATRYOSHKA DOLLS

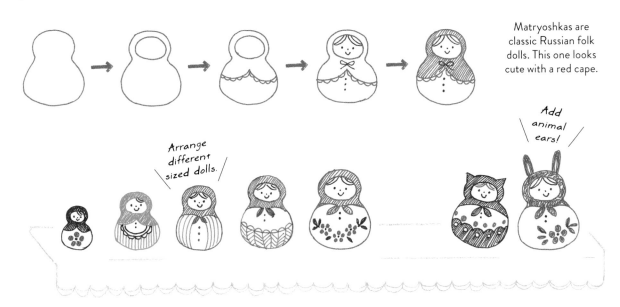

Matryoshkas are classic Russian folk dolls. This one looks cute with a red cape.

Arrange different sized dolls.

Add animal ears!

DALA HORSE

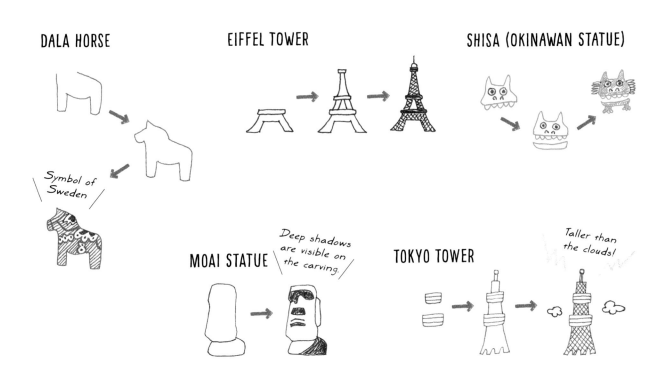

Symbol of Sweden

EIFFEL TOWER

SHISA (OKINAWAN STATUE)

MOAI STATUE

Deep shadows are visible on the carving.

TOKYO TOWER

Taller than the clouds!

ICON ILLUSTRATIONS

Use these cute little illustrations to decorate your diary, planner, or calendar. They can help you stay organized and celebrate special events.

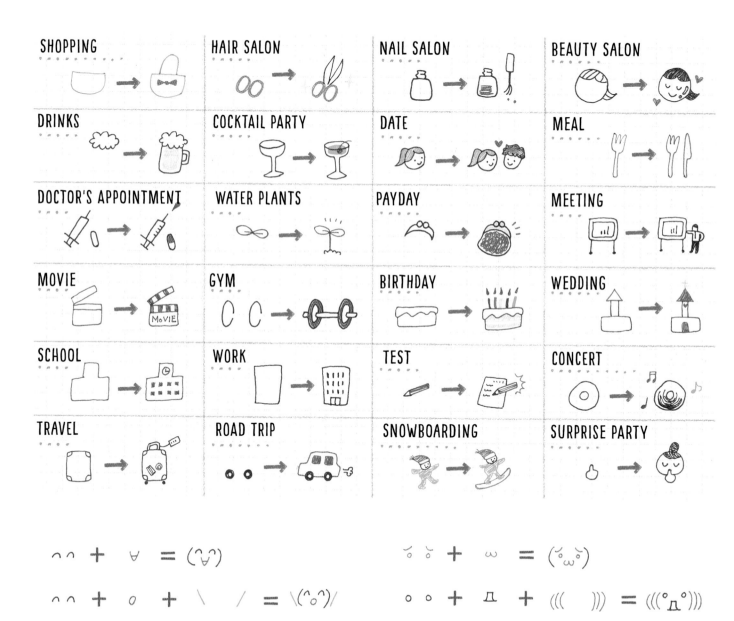

BIRTHDAY

DRINKS

MEAL

DATE

DINNER DATE
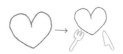

GYM

YOGA

HAIR SALON

NAIL SALON

BEAUTY SALON

SHOPPING

MOVIE

TRAVEL

PAYDAY

HOSPITAL

WORK

MEETING

BUSINESS TRIP

SCHOOL

TEST

SUNNY

Use orange and yellow for a cheerful color scheme.

RAIN

Draw raindrops dripping from an umbrella.

LIGHTNING
Use jagged lines for a bolt of lightning.

SNOW

Add a hat for a friendly look.

RAINBOW
Draw clouds at the base of the rainbow.

WINDY
Draw a cloud character blowing a gust of wind.

CLOUDY

Draw a fluffy oval.

RAIN SHOWER

Draw a smiley face on a raindrop.

STORM
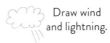
Draw wind and lightning.

SNOWFLAKE
Draw an asterisk then decorate the tips with V shapes.

TORNADO

Use an inverted triangle shape for the cloud.

 BIRTHDAY

 DATE

 MEAL

 COFFEE

 DRINKS

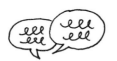 MEETING

 WORK

 PAYDAY

 TEST

 PAYMENT

 LESSON

 TRAVEL

 SPORTS

 CONCERT

 PLAY DATE

 DAY OFF

 SHOPPING

 MOVIE

 HAIR SALON

 HOSPITAL

 SUNNY

 CLOUDY

 RAINY

 SNOW

 RAINBOW

SPECIAL LESSON: SPEECH BUBBLES

SIMPLE SPEECH BUBBLES

Use fluffy lines for a fun impression.

Use an oval shape for a classic look.

Use an arrow to get someone's attention.

Jagged lines are also eye catching.

Use dotted lines for information that is supposed to be a secret.

Use curly lines for a casual look.

Use soft, wavy lines to express thoughts and ideas.

Layer colors for a unique look.

Use sharp points to catch someone's attention.

Use wavy lines for worried thoughts.

For an easy-to-draw speech bubble, make an oval and overlap the ends.

Use a rectangular shape if you have a lot of text.

USING SPEECH BUBBLES TO EXPRESS EMOTIONS

EXCITED

Use curly lines and add music notes to emphasize the joy.

MAD

Use sharp points and add angry bursts.

SAD

Soft lines and teardrops convey sad feelings.

NERVOUS

Use a wavy outline and to express anxious feelings.

MESSAGES FOR SPECIAL OCCASIONS

Use these illustrations to create heartwarming messages in celebration of birthdays, weddings, and other memorable events.

BIRTHDAYS

Make sure to leave space for writing a special message.

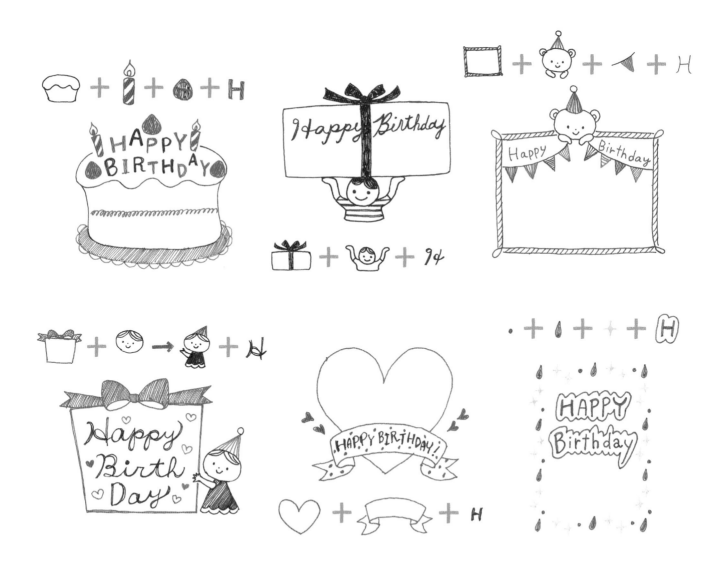

WEDDINGS

Use these stylish illustrations to celebrate a wedding.

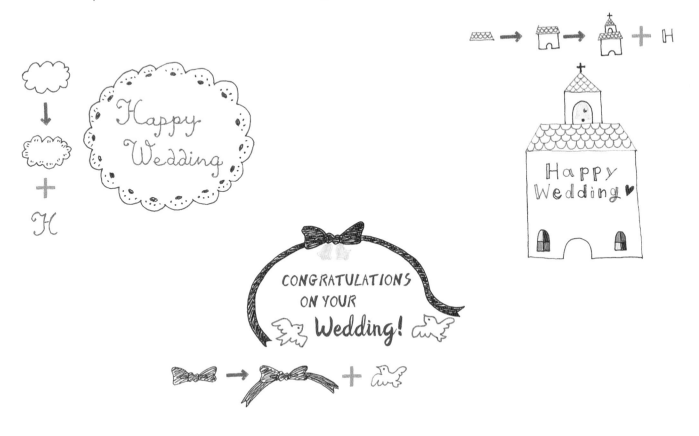

NEW BABY

Celebrate the birth of a baby with one of these cute illustrations.

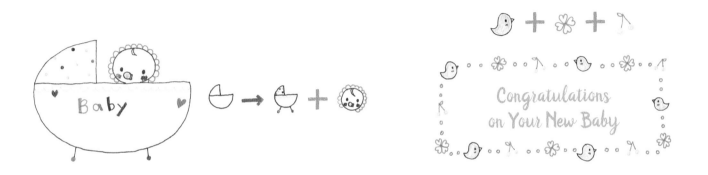

SPECIAL EVENTS

These designs are inspired by special occasions, such as weddings and birthdays. Use them to decorate cards and invitations.

WEDDINGS

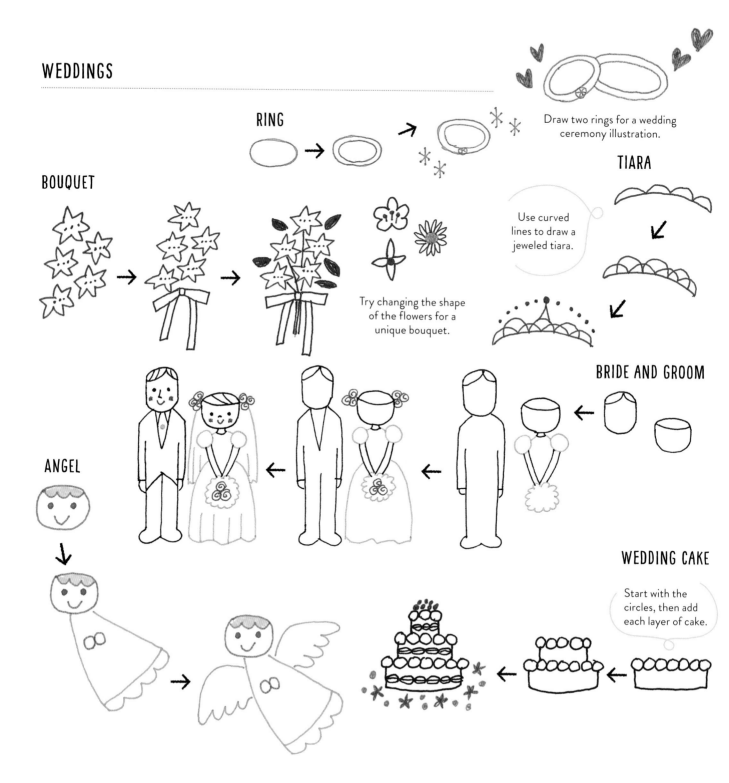

RING

Draw two rings for a wedding ceremony illustration.

TIARA

Use curved lines to draw a jeweled tiara.

BOUQUET

Try changing the shape of the flowers for a unique bouquet.

BRIDE AND GROOM

ANGEL

WEDDING CAKE

Start with the circles, then add each layer of cake.

BIRTHDAYS

PRESENT

PARTY CRACKER

BIRTHDAY CAKE

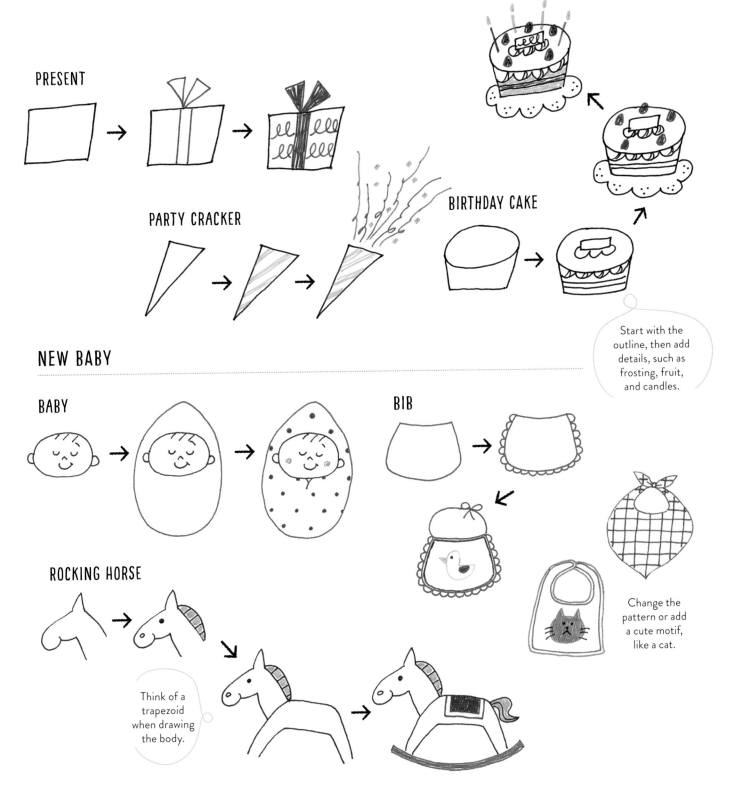

Start with the outline, then add details, such as frosting, fruit, and candles.

NEW BABY

BABY

BIB

ROCKING HORSE

Think of a trapezoid when drawing the body.

Change the pattern or add a cute motif, like a cat.

SEASONAL MOTIFS

These illustrations are inspired by the four seasons. Use them to celebrate the special events and holidays associated with that time of the year.

SPRING

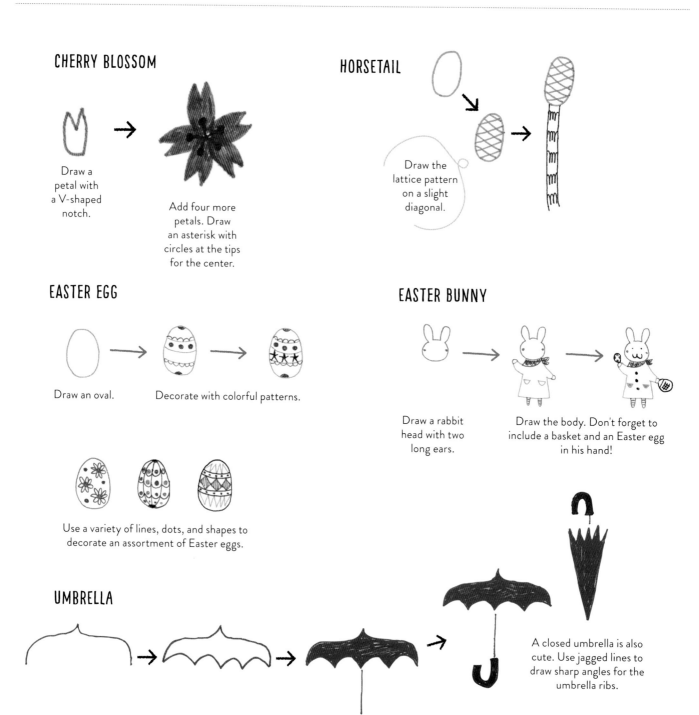

CHERRY BLOSSOM

Draw a petal with a V-shaped notch.

Add four more petals. Draw an asterisk with circles at the tips for the center.

HORSETAIL

Draw the lattice pattern on a slight diagonal.

EASTER EGG

Draw an oval.

Decorate with colorful patterns.

Use a variety of lines, dots, and shapes to decorate an assortment of Easter eggs.

EASTER BUNNY

Draw a rabbit head with two long ears.

Draw the body. Don't forget to include a basket and an Easter egg in his hand!

UMBRELLA

A closed umbrella is also cute. Use jagged lines to draw sharp angles for the umbrella ribs.

SUMMER

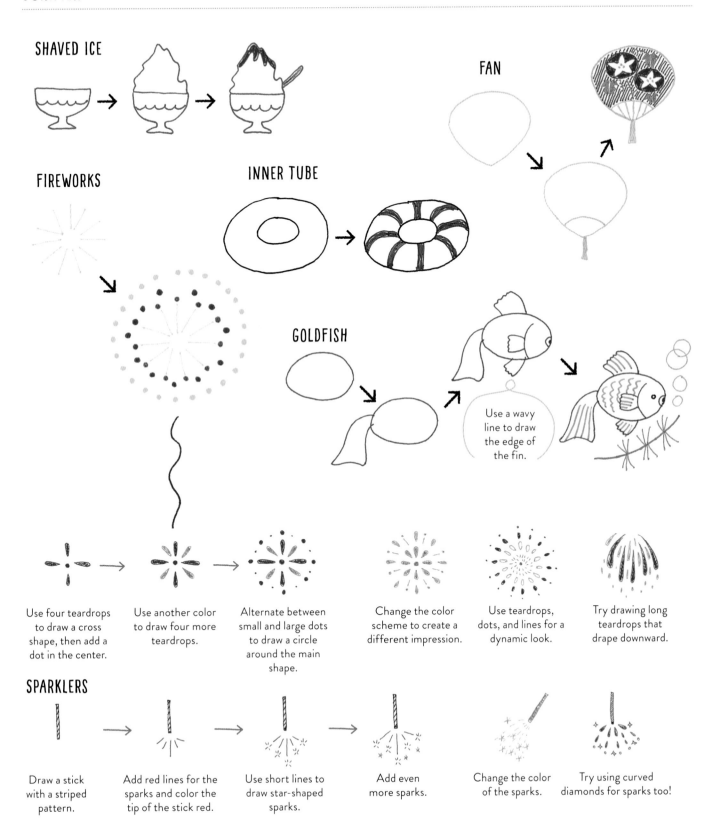

SHAVED ICE

FAN

FIREWORKS

INNER TUBE

GOLDFISH

Use a wavy line to draw the edge of the fin.

Use four teardrops to draw a cross shape, then add a dot in the center.

Use another color to draw four more teardrops.

Alternate between small and large dots to draw a circle around the main shape.

Change the color scheme to create a different impression.

Use teardrops, dots, and lines for a dynamic look.

Try drawing long teardrops that drape downward.

SPARKLERS

Draw a stick with a striped pattern.

Add red lines for the sparks and color the tip of the stick red.

Use short lines to draw star-shaped sparks.

Add even more sparks.

Change the color of the sparks.

Try using curved diamonds for sparks too!

FALL

JACK-O'-LANTERN

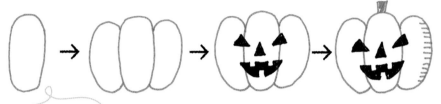

Start with the middle section of the pumpkin.

MUSHROOMS

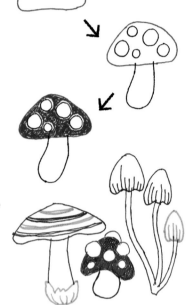

Mushrooms come in all different shapes and sizes. Draw a variety to showcase their uniqueness!

CHESTNUTS

Use short, crossed lines to draw spiky burrs for the outer casings of the chestnuts.

BAT

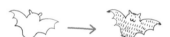

Draw pointy wings.

Add the face and color the body with short vertical lines.

WITCH

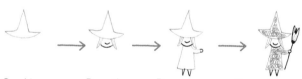

Combine a triangle and a semicircle to draw a pointed hat.

Draw the face and hair beneath the hat.

Draw an arm extending out from the body. Use inverted triangles for the legs.

Draw a broom in her hand. Color the clothes dark blue.

VAMPIRE

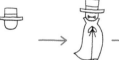
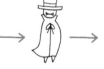

Draw a semicircular face under a rectangular hat.

Draw a cape fluttering in the wind. Use two triangles for the fangs.

Color the hat and cape with diagonal black lines.

Use red as an accent for the hat and shoes.

MUMMY

Draw loose limbs.

Draw random lines to create the bandages.

Leave a few bandages hanging from the arms.

COFFIN

Draw a vertically elongated hexagon.

Add a cross and thick outlines.

Color with purple and green for a spooky look.

WINTER

SANTA CLAUS

Use fluffy lines to draw a triangular beard.

Santa carries a big bag of presents over his shoulder.

MITTENS & SCARF

CHRISTMAS TREE

Use colorful circles to decorate the tree with ornaments.

REINDEER

Draw a round body.

Use a bright red circle for the nose.

Draw two antlers. Add a blanket to the reindeer's back to keep him warm in the snow.

SNOWMAN

Stack a small circle on top of a large one.

Add eyes and a carrot nose to the small circle.

Add a bucket-shaped hat. Dress your snowman any way you'd like!

STOCKING

Make the bottom round.

Add a bow and color using red and green.

WREATH

Start with a red bow.

Draw two circles using fluffy lines.

Color the wreath using curly lines and add a bell.

ORNAMENT

Draw the arms extending from the body.

Use short diagonal lines to roughly color in the body.

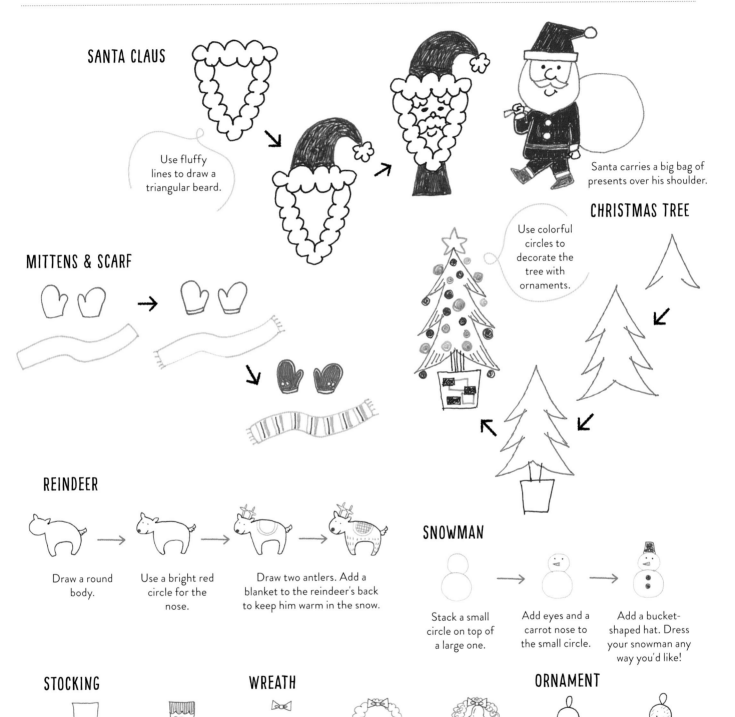

THE ZODIAC

These illustrations feature the twelve Chinese zodiac signs. In the Chinese zodiac, animals represent personality traits associated with birth year.

These illustrations were created using two different face and body shapes. Combine the face and body style noted for each animal to complete the illustration.

RAT A + a

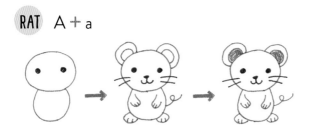

OX B + a

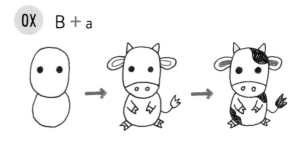

TIGER A + a

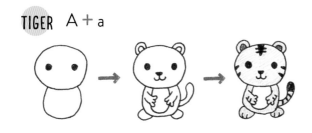

HARE A + a

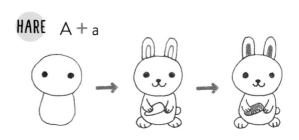

DRAGON B + b

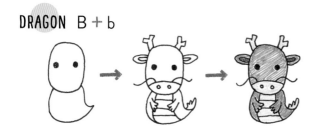

SNAKE A + a

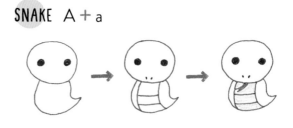

HORSE B + a

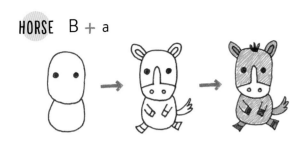

SHEEP A + a

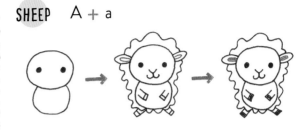

MONKEY A + a

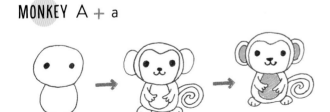

ROOSTER A + a

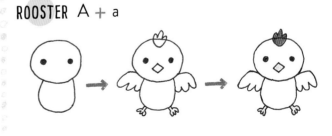

DOG A + a

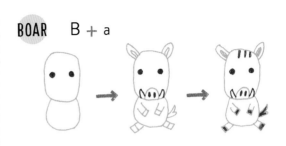

BOAR B + a

NUMBERS & LETTERS

Add some personality to your writing! Use fun colors and unique line styles to create special effects. Combine decorative text with doodles for one-of-a-kind greeting cards and invitations.

NUMBERS

NORMAL 0 1 2 3 4 5 6 7 8 9

DIGITAL

0 1 2 3 4 5 6 7 8 9

Inspired by a digital clock, these numbers are composed of straight lines rather than curves. You can even leave a little space at the joints for a realistic look.

OUTLINE

0 1 2 3 4 5 6 7 8 9

Start by drawing an ordinary number, then add a vertical line. You can also color in the space created by the addition of the vertical line.

SPIRALS

0 1 2 3 4 5 6 7 8 9

Use curly lines to make each number. This technique creates a fun, playful look when drawn on a large scale.

BUBBLE LETTERS

0 1 2 3 4 5 6 7 8 9

Use horizontal lines to shade from dark to light and create an ombré effect.

ROMAN NUMERALS

I II III IV V VI VII VIII IX X

Use Roman numbers for a more traditional look. Make the body thicker for added sophistication.

MODERN ROMAN NUMERALS

I II III IV V VI VII VIII IX X

Eliminate the top lines for a modern look.

NORMAL

ABCDEFG
abcdef9

DOTTED LINES

ABCDEFG
abcdef9

Use dotted lines to create
a warm impression.

OFFSET

ABCDEFG
abcdef9

Start by drawing the letter
normally, then shift to the
right a bit and redraw the
same letter again.

EMBROIDERED

ABCDEFG
abcdef9

Use thick zigzag lines to make
the letters appear as if they've
been embroidered.

FILLED

ABCDEFG
abcdef9

Color in the hollow areas of
each letter. Use a contrasting
color for a playful look.

FLUFFY

ABCDEFG
abcdef9

Use fluffy lines to make thick
bubble letters.

OVERLAPPING

ABCDEFG
abcdef9

Make bubble letters by
overlapping the different
components of each letter and
leave them unfilled.

SQUARE BUBBLE

ABCDEFG
abcdef9

These slightly distorted bubble
letters have a fun, video-game
inspired look.

VARIATION

CURSIVE LETTERS

Use cursive writing to create an elegant impression.

UPPERCASE

ABCDEFGHIJKLM
NOPQRSTUVWXYZ

LOWERCASE

abcdefghijklm
nopqrstuvwxyz

DECORATIVE LINES

Use simple lines and small motifs to create eye-catching designs that draw attention to your messages and illustrations. Once you decide on the pattern, change the length, color, or arrangement for interesting variations.

SIMPLE LINES

STRAIGHT

Draw a horizontal line. Don't worry if it's not perfectly straight.	Layer two lines drawn in similar colors.	Three similarly colored lines create a gradated effect.

WAVY

Try to keep the waves similar in size and shape.	Layer two wavy lines drawn in similar colors.	Draw two wavy lines that are slightly shifted or offset.

JAGGED

Concentrate on the movement of the pen when drawing a jagged line.	Stack two jagged lines drawn in the same color for a bold look.	Use complementary colors for a stylish impression.

CURLY

Draw the line so the loops face downward...	Or upward. It's alright if the loops are slightly different sizes.	Try larger loops for a playful impression.

DOTTED

Try to keep the spacing even, but don't worry if some lines are slightly longer than others.	Intentionally change the length of the lines for a bit of variation.	Draw double dotted lines for a bold look.

FLUFFY

A simple fluffy line has a lacy, feminine look.

DIAGONAL JAGGED

Draw sharply angled points for an edgy, attention-getting look.

BUMPY LINE

Try this decorative up-and-down-style line.

WINDING

This curvy pattern creates a unique impression.

VARIATION

LINE COMBINATIONS

STRAIGHT + FLUFFY

Draw two different style lines for a dynamic look.

STRAIGHT + DOTTED

Alternate the line length for a custom look.

THICK + THIN

Stack lines of varying thickness.

CHAIN

Add a semicircle to the end of each line section for a three-dimensional look.

RAILROAD

This style also looks good when drawn with winding lines.

ACCENTS

Use short, colorful lines as an accent.

DIAGONAL

Arrange diagonal strokes at equal intervals to create a thick line.

MOTIF LINES

DOTS

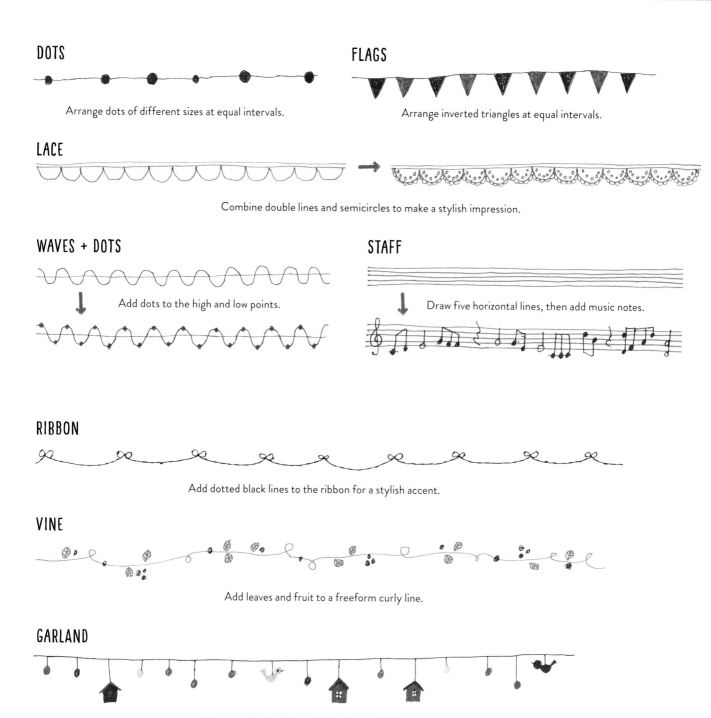

Arrange dots of different sizes at equal intervals.

FLAGS

Arrange inverted triangles at equal intervals.

LACE

Combine double lines and semicircles to make a stylish impression.

WAVES + DOTS

Add dots to the high and low points.

STAFF

Draw five horizontal lines, then add music notes.

RIBBON

Add dotted black lines to the ribbon for a stylish accent.

VINE

Add leaves and fruit to a freeform curly line.

GARLAND

Draw small, colorful motifs hanging at different heights.

HEARTS	♥♡♡ → ♥♡♥♡♡♥♡♥♡♥♡♥♡♥♡♥	Looks cute when the hearts are drawn on slightly different angles.
STARS	✦·✦· → ✦·✦·✦·✦·✦·✦·✦·✦·	Sprinkle small stars among larger ones.
BOWS	🎀🎀🎀 → 🎀🎀🎀🎀🎀🎀🎀🎀🎀	Arrange the same motif in different colors.
SNOWFLAKES	❉·❉° → ❉·❉·❉·❉·❉·❉·❉·❉·	Alternate large and small snowflakes for a natural look.

VARIATION

ILLUSTRATED LINES

Combine lines with different illustrations to create adorable doodles.

CONNECT THE MOTIF + LINE

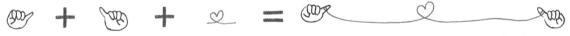

Draw a red thread strung between two hands.

MOTIFS ABOVE THE LINE

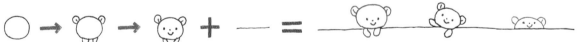

Draw animal faces or arms above the line to make them look like they're peeking out or hanging over the edge.

LINE EXTENDING FROM THE MOTIF

Draw a few twists and curves in the line for a bit of movement.

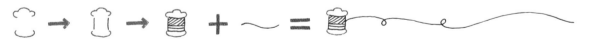

A jagged line makes for a more realistically drawn pencil line.

FRAMES & BORDERS

These designs make simple messages more colorful. Use color and pattern to express your feelings and highlight what you want to say.

RECTANGULAR FRAMES

This basic frame shape is made by drawing a small rectangle inside a larger one.

BASIC RECTANGULAR FRAME

Draw two rectangles.

AIRMAIL

Add blue and red diagonal lines and a stamp to create an airmail-inspired design.

POLKA DOTS

After drawing the polka dots, color the frame using diagonal lines.

CHECKERED

Color the squares alternately.

WOOD GRAIN

Draw layers of circles and semicircles to capture the look of the wood grain.

Get creative...use rectangular objects as inspiration for your border designs.

STAMP

MEMO

ENVELOPE

Draw lines, then embellish with motifs to create a frame.

UNIQUELY SHAPED FRAMES

You can use all different shapes to make beautiful designs.

Bon appetit!

Hi, how are you?

Just draw motifs on the corners to create a stylish frame.

See you again soon!

Welcome to

our home!

Write a message inside the frame.

DOODLE FRAMES

Use the silhouette of an image to create a frame.

APPLE + ELEPHANT

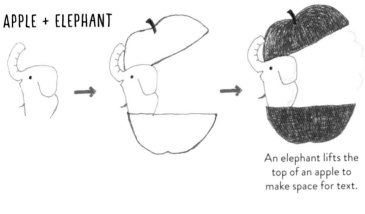

An elephant lifts the top of an apple to make space for text.

PEAR + SQUIRREL

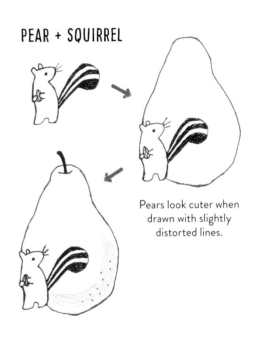

Pears look cuter when drawn with slightly distorted lines.

CUPCAKE

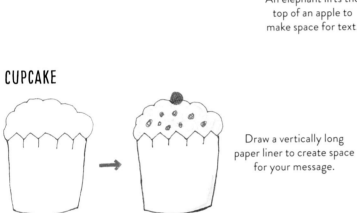

Draw a vertically long paper liner to create space for your message.

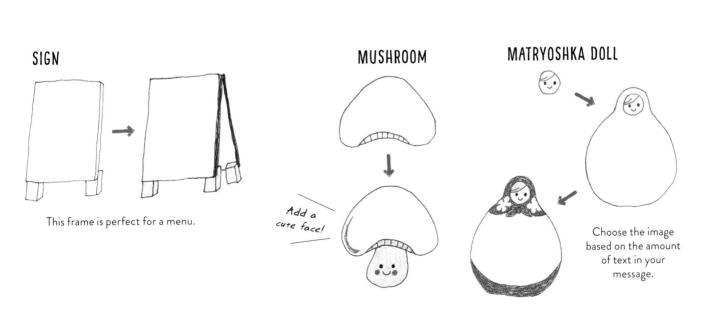

SIGN

This frame is perfect for a menu.

MUSHROOM

Add a cute face!

MATRYOSHKA DOLL

Choose the image based on the amount of text in your message.

CREATIVE FRAMES

Once you've mastered the basics, combine doodles and lines to create interesting frames.

CHANGE THE SIZE

Adjust the size and shape of the door to suit your needs.

REPEAT DESIGN ELEMENTS

Align a row of houses to make a frame for a zip code or address.

USE UNIQUE SHAPES

MAKE A SCENE

Combine doodles and decorative lines
to create a unique scene.

ADD A CHARACTER

Draw a character along the top edge
to make her look like she's peeking out
from behind the frame.

Try a cute book-shaped frame

CHANGE IT UP

Bonjour.

You can create many different designs just by changing the character.

SPECIAL LESSON: BORDER & FRAME INSPIRATION

BORDERS

FLAGS

Decorate triangular and rectangular flags with simple shapes and lines.

HEARTS

Make a line by overlapping small and large hearts.

SCISSORS

Alternate scissors in different colors for a crafty look.

RIBBON

Draw bows at the beginning and end of the line.

STARS

Alternate stars of different sizes to create a sparkly border.

YARN

Draw a ball of yarn and some knitting needles for an eye-catching design.

LEAVES

Draw different styles and colors of leaves for a nature-inspired border.

MUSIC NOTES

Arrange colorful music notes for a lively look.

ANIMALS

Draw friendly animal faces, such as bears, bunnies, cats, and mice.

FRAMES

DIAGONAL LINES

TAPED CORNERS

TWO-SIDED

CORNER TABS

RIBBON

APPLE

SNAKES

CIRCLES

OPEN BOOK

DESSERT

BEAR

BUNNY + CARROTS

aque (Megumi Akuzawa) is a Virgo who specializes in drawing cute illustrations of kids and animals. www.aquemeg.com

Junko Akino is known for her fun and cute illustrations. Her work has been featured in books and magazines. www.akinojunko.com

Asaki Yacai specializes in yummy food-themed illustrations.

Chikako Abe is a freelance illustrator whose work has been featured in books, magazines, advertisements, and on websites. She is a dog lover and has several dachshunds. www.lifesizelife.com

Masako Inoue is a freelance illustrator who specializes in whimsical freehand drawings. www.fuufuukettle.com

amycco. (Emiko) is known for her fun and simple illustrations, which have been featured in books and magazines. She loves birds and traveling in Europe. www.amycco.com

Megumi Ochiai has created illustrations for books, magazines, ads, apparel, logos, and more. She is known for her simple, nature-inspired designs. www.ochiai-megumi.com

cotolie became a freelance illustrator after working as a product designer. Her soft, watercolor illustrations have been used for a variety of children's books and magazines. www.cotolie.com

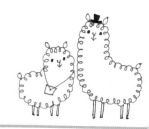

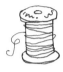

Kaori Takata is known for her warm, lovely illustrations. Her artwork is inspired by women and children.

Chiko creates cheerful and expressive illustrations that are beloved by people of all ages. She specializes in drawing animals and children. www.fuwawas.com

Terue Fujiwara is known for her watercolor paintings, pen illustrations, and collages. She creates illustrations for stationery, paper goods, and books. www.suzunarihappy.com

macco is popular for her feminine, fashion-inspired illustrations. She plays piano and enjoys sewing in her spare time. www.maccomac.com

miyako is known for her cute illustrations of kids and animals. www.miyako385.com

Hiroko Yokoyama is a self-taught freelance illustrator and mom of three. She enjoys spreading cheer through her artwork. www.yokoyama-hiroko.com

Miki Yonezawa became a freelance illustrator after working for a design firm. She regularly contributes to books and magazines and enjoys designing characters. www.yonezawa.df-cue.com

yuki is active in a wide range of creative fields, including illustrating, stamp making, and kokeshi doll making.

Rieko Wakayama is known for her comical illustrations in books and magazines. www.ridarida.web.fc2.com